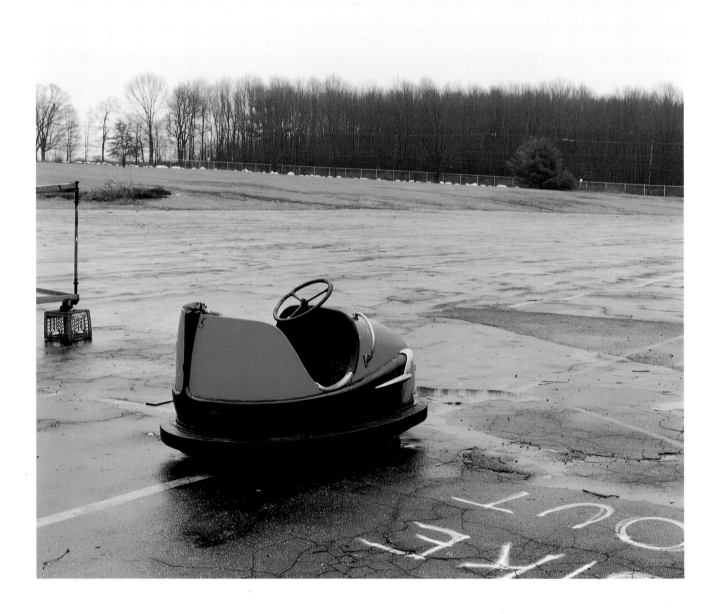

INSIDE THE LIVE REPTILE TENT

The TWILIGHT WORLD of the CARNIVAL MIDWAY

Photographs by JEFF BROUWS
Text by BRUCE CARON

CHRONICLE BOOKS
SAN FRANCISCO

Library of Congress Cataloging-in-Publication-Data
Brouws, Jeffrey T.
Inside the Live Reptile Tent : the twilight world of the carnival
midway / photographs by Jeff Brouws ; text by Bruce Caron.
p.cm.
Includes bibliographical references.
ISBN 0-8118-2824-7
1. Carnivals. 2. Carnivals—Pictorial works.
I. Caron, Bruce. II. Title.
GV1835 .B76 2001
791'.1—dc21 00-057087

Printed in Hong Kong.

Designed by Wendy Burton Brouws, For A Small Fee, Inc.

Distributed in Canada by Raincoast Books
9050 Shaughnessy Street
Vancouver, British Columbia V6P 6E5

10 9 8 7 6 5 4 3 2 1

Chronicle Books LLC
85 Second Street
San Francisco, California 94105

www.chroniclebooks.com

For Wendy, again and again

PICTURE CREDITS

Black-and-white photographs on pages 73, 78, 91, and 93
copyright © 2000 Jeff Brouws
Black-and-white photographs on pages 84, 85, and 86
copyright © 2000 Tom Moore
All other black-and-white photographs are copyright ©
Library of Congress and were selected from
the following three collections:

Library of Congress, Prints & Photographs Division, Farm Security
Administration / Office of War Information Collection
 pages 6, 8, 9, 11, 14, 17, 19, 23, 68, 71, 72, 75, 81, 82,
83, 88, 92

Library of Congress, Prints & Photographs Division, Detroit
Publishing Company Collection
 pages 20 and 80

Library of Congress, Prints & Photographs Division,
Theodor Horydczak Collection
 pages 12 and 21

Frontispiece: RED BUMPER CAR / Connecticut 1991
Caption for photograph on pages 60–61:
MARILYN BUTTONS / Ventura, California 1994
Caption for photograph on pages 106–107:
CIGARETTE HAND / Ventura, California 1994
Caption for photograph on pages 118–119:
SKYDIVER (MAGENTA) / Santa Maria, California 1988

TABLE OF CONTENTS

Entrance to the Midway
Glen Echo, Maryland
David Myers
1939

A SEA OF QUESTIONABLE TASTE

Tracking the architecture of the American carnival as it careens through the twentieth century is a ride worthy of the pleasure grounds that speak this spatial language best. Jeff Brouws's photographic documents reveal an architectural style as self-assured as it is preposterous.

Decades on the front lines of flagrant huckster capitalism have made the carnival a lean, mean, selling machine. Its seductions are legendary, and rarely subtle. The carnival always offers us more than we expect, and somehow makes us happy even when our pockets are empty. Its transactions are simple ones: a token of cash in exchange for instant, if momentary, sensual gratification.

The midway mostly trades in fakery, in risk rides that are not risky (except to your lunch), and in games where winning borders on the impossible, all wrapped in an aesthetic that trolls out in a sea of questionable taste beyond kitsch.

Carnival Ride
Brownsville, Texas
Arthur Rothstein
1942

The price is always just low enough to make us think about taking a chance, and then maybe just one more.

Today the traveling carnival is in visible decline. Its century is over. It now caters almost entirely to children, who these days have other amusements to keep them from the reptile tent.

The story of the American traveling carnival tells us something about ourselves. It shows us that we are today living, as we have long lived, well within the glare of the lowly midway. Our memories of carnivals remain vivid: weekends we took as kids to amusement parks with the family, chattering and trembling in anticipation, clinging to mountains of cotton candy balanced on a stick and then clutching at the sleeve of an older sibling when the coaster hit the top of the first incline. The annual carnivals that showed up every year in our own neighborhoods, in that vacant lot over by the railroad tracks, where one day there is nothing but litter and weeds and the next, towering metal contraptions with names like "The Zipper" and "Tilt-a-Whirl." The films we've watched, where carnival settings have offered hundreds of places for second-act shenanigans, where hapless victims are always in imminent danger, and where the hero and heroine find the occasion for that first kiss. Our weekly visits to malls and to theme restaurants that borrow shamelessly from this carnival heritage, creating a visual midway with a Cadillac half-buried in its façade, or a neon jungle of flashing signage on its walls—the same kind of signage that lit the original Midway Plaisance in Chicago in 1893 and was later transplanted to roadside tourist traps to lure the gullible off the interstate.

Then there is Las Vegas, perhaps the largest

carnival in the world, and the hundreds of wannabe Vegases sprouting up on Native American reservations across the nation. Carnivals indeed, where the economic equation—that simple transaction between desire and cash—is pushed to the point where the transaction is itself the ride, and the higher the value, the greater the thrill.

The local carnival is rarely a life-or-death affair, either physically or financially. In fact, the whole idea is to leave the customer (the "mark") poorer, if a little wiser, but most certainly in a mood to return again and again. Just as sex was once described by Woody Allen as "the most fun you can have without laughing," the carnival offers the most fun you can have laughing at yourself. The midway provides an occasional experience to remind us that sometimes life is a dish best served right smack in the face.

Sociologists occasionally admit that how a society plays can say a lot about the bigger picture: about its freedoms and collective imagination, and even about power relationships. As we journey from the century of the American carnival into a world of computer games and home theaters, we might want to reflect on how the time we won't spend at the carnival in the coming century will change us as a nation. Have we outgrown the traveling carnival, or are we simply no longer up to it? To say we need places like the carnival, and times when we tilt away from the mundane in order to know better how to live, implies that our lives are assembled from the diversity of our skills and the complexity of our desires. Certainly we can do with less, but then we are lessened by this making-do.

The American traveling carnival was born from the reckless entrepreneurialism of the turn of the twentieth century, a time when the frontier had just

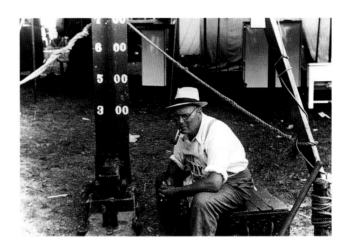

Test Your Strength
Central Ohio
Ben Shahn
1938

been closed and a nation was building itself across a large continent. The carnival took on the mantle of medicine shows and circus midways and grew into the highlight of many a hot summer in most American towns. It had its day in the sun. And surely something new is ready to emerge, something not tied to the mechanical contraptions that carnivals still lug from fairground to fairground.

While many would argue that the carnival brings out only the worst in us, I would have to disagree. The American carnival midway has always shown us to be both better and worse than we imagined, at once bolder and less clever. It responds to who we are when we are not putting on our carefully managed personas. It offends us only when it shows us more than we want to see.

The carnival midway beckons us from our sequestered modern lifestyle, challenges us to give in to our physical urges and the thrill of vertiginous flight. The midway makes us all marks, suckers determined to have the last laugh, and then ending up laughing at ourselves for having such a good time getting taken. But the midway offers still more, opening up a discourse of dangerous emotions and destructive impulses. It is not just some low-rent Disneyland, but a vestige of more serious games, and of times past (and pastimes) when the self was determined more directly by physical challenges. Here is also the province of the bizarre, of giant rats and fun-house mirrors. The tragic and the erotic share equal billing in the show.

The midway takes the fetishes with which we surround ourselves and pushes them into grotesque relief. One of the last fun-dangerous places we can encounter, it saves us from modernity's empty promises of personal safety, which have lost their

significance in the face of the omnipresence of media violence. While it flounders today in tawdry obscurity, we must not lose sight of the midway, for it teaches us fearlessness. It makes us bolder and somehow better, and always gives us another chance to catch the brass ring.

The American carnival midway is nothing if not light on its feet. It is certainly nimble enough to overcome changing economic and technological circumstances. The coming digital midway will open up animated worlds spinning in gut-wrenching 3-D at five dollars a ride. (That corn-dog you just finished will still be in danger.) Tomorrow's sideshow games will feature virtual interaction with top celebrities. Something new and wonderful with lasers and holograms will take the place of the attractions you see in these photographs. But these new attractions will owe much to their tawdry forebears who first ventured into the cultural void way out beyond kitsch.

The essays that follow explore carnival histories and spaces, peeking under the flap of this live reptile tent. They serve to elaborate on the photographs, to show how long decades of glad-handing commerce—in the service of corporal (rather than corporate) desire—have brought us a form of American amusement that deserves better than it's got, and is worth a long second look.

Reference:
Brouws, Jeff, Bernd Polster, and Phil Patton. *Highway: America's Endless Dream*. New York: Stewart, Tabori & Chang, 1997.

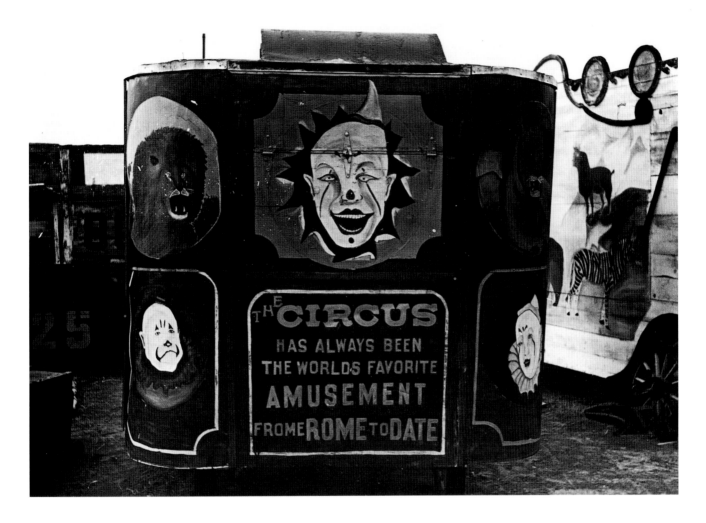

Circus Wagon
Alger, Sheridan County, Montana
Russell Lee
1937

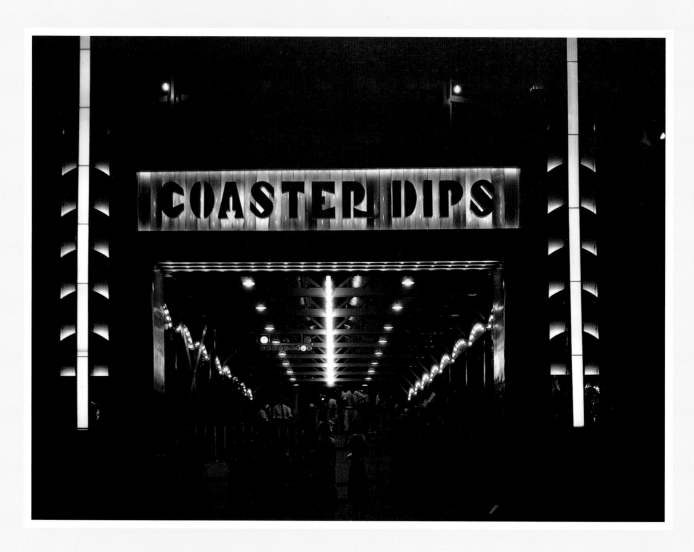

Coaster Dips, Tunnel View at Night
Glen Echo Amusement Park, Maryland
Theodor Horydczak
1935

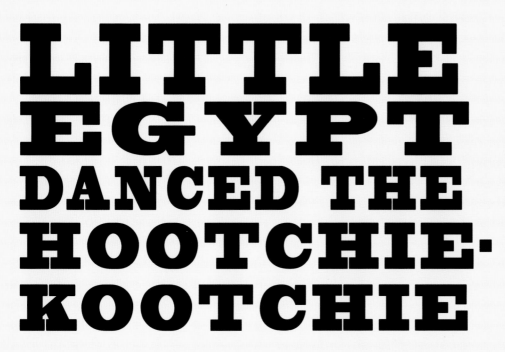

LITTLE EGYPT DANCED THE HOOTCHIE-KOOTCHIE

For the generation born after the American Civil War, those millions who grew up (or arrived from Europe or Asia) during decades of galloping economic expansion and just-as-sudden recession, the coming end of the nineteenth century heralded the beginning of a new, distinctly American, century. During the nineteenth century's final decade, the United States encountered technological advances that would reweave the very fabric of work, society, politics, and, perhaps most of all, leisure.

The 1880s marked the heyday of the great circuses, with Barnum and Bailey, for years bitter rivals, joining up to create "The Greatest Show on Earth." By 1890, minstrel and medicine shows and roaming

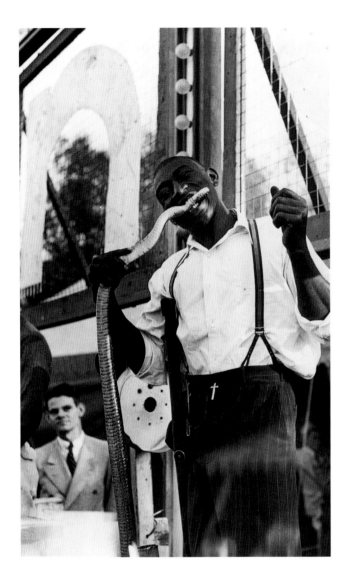

Snake Eater
Donaldsonville, Louisiana
Russell Lee
1938

theatrical companies competed with lantern shows and traveling panoramas to entertain what was still a nation of small towns. Most of the entertainers were white and male (or else some form of trained animal), although women headlined certain types of entertainment, and costumed minstrels and clowns in blackface were common. African and Native Americans found work mainly as caricatures of their communities, or at the bottom of the heap of carnival entertainers: as snake- or rodent-eaters (the original meaning of the term "geek"). This period was also the apex of the "Gilded Age," an era when urban and domestic architecture piled ornaments upon pediments and sheathed new downtown skyscrapers in thick garlands of terra-cotta fruits and flowers.

Most historical accounts of this time point to technological and industrial changes as the era's defining moment. Electrification put factory work on a twenty-four-hour day, which required transportation and other services to operate late into the evening and resume early in the morning. The social fabric of the illuminated city stretched to cover the night as day. Such changes, however, are only a part of the picture of early urban modernity in America.

Factories are only one story in an epic of an epoch, if you will, that continues to unfold to this day. While the modern factory inspired a generation of modernist architects, the era's modern amusement places, from London's Crystal Palace of 1851 to Coney Island's Dreamland in 1904, attracted factory workers by the millions to a novel form of entertainment: the mass consumption of a spectacle. I would submit that, since the beginning of the twentieth century, no changes have been as profound

as those that have occurred outside the factory—in homes, on the streets, and particularly in places and practices of popular leisure, itself a concept born in this era. And for all of the mechanical efficiencies of the modern factory, this remained until very recently, when the digital revolution started to have major impacts, remarkably unchanged since Henry Ford's first production line. By comparison to modes of industrial production, the modes and technologies of amusement appear robustly dynamic. And this dynamism was most apparent at the start of America's century of the carnival.

Between the close of the Gilded Age and the Great War, a period of less than three decades, we can locate nascent technologies for the jukebox, the radio, the automobile, the cinema, theatrical electric lighting, the loudspeaker, and every mechanized amusement ride from the Ferris wheel to Splash Mountain. Photography was already moving into popular forms of use, and early telephone prototypes were posed to replace the telegraph. Thirty years after the transcontinental railroad completed its first east-west link, the United States had half of the railroad mileage in the entire world. By the end of the nineteenth century, more than half of the hourly workers worked a ten-hour day, down from twelve hours. While economic expansion and depression alternately rolled through the workplace economy, America's appetite for amusement kept growing, though not, it seems, as fast as its cultural imagination.

GRAND EXPOSITIONS

The final decade of the nineteenth century witnessed a procession of giant fairs, which, in turn, promoted dozens of statewide events and hundreds of county and city fairs, each one copying some features of the huge world expositions. Chief among these expositions (at least in the United States) was the 1893 World Columbian Exposition in Chicago. This World's Fair sold more than twenty-five million tickets and introduced the world to a nation not only conceived in liberty but convinced of its own greatness, and eager to try just about anything as long as it was new, electrical, and enormous, or simply bizarre.

The Exposition tapped into imaginations both civic and serendipitous. The former imagination built the White City Court of Honor buildings, standing shoulder-to-shoulder as new-classical colossi—an inspiration for an entire new wave of City Beautiful architecture that would remake the American civic plaza. The latter built the world's first midway: a mile-long amusement corridor, attached at one end to the main fair site and at the other to a wide variety of emerging cultural and sexual fetishes.

On the midway, Little Egypt danced her hootchie-kootchie—a dance that would soon arrive, in some derivative form, in nearly every small town in America. "Oddities" from around the globe, and "villages" of "savage" (and so, naked) peoples amused the hordes of Midwesterners and served as a reminder of the advances of (white) civilization. Here too, George W. Ferris built his first great wheel, soaring 250 feet into the air. But perhaps the most popular attraction at the Exposition was novel uses of electricity. From the creation of the first moveable sidewalk to the first all-electric kitchen, electricity sparked a bonfire of imagination among fairgoers. Tom Edison and George Westinghouse competed to outdo each other in

the creation of an entire new world of light and mechanical wonder.

One of the first spinoffs from the Chicago and other great expositions was the establishment of permanent state fairgrounds and annual fairs as a normal operation of state government. And no state fair worth its salt would deny the midway its place on the grounds. In fact, the size of the midway, more than any other feature, became a boasting point for the state fairs. The mushrooming of state and county fairs opened a wide door for thousands of new carnival entertainers, from comedians to death-defying high-divers.

The surviving medicine shows attached themselves to these events as well, when they could, and small traveling circuses added midway entertainments as sideshows to capture more of the crowd's cash. In the cities, the beginnings of vaudeville formed from the ranks of circus, medicine, minstrel, and carnival performers. By the end of 1900 there were sixty-seven theaters in the United States devoted to vaudeville, and two in the works in London.

The population of the United States had nearly doubled in twenty years between 1881 and 1901, and much of this new population headed to the cities and towns, where a new feature of the leisure industry was about to take off: permanent commercial amusement sites. Traveling medicine shows were now in full decline, in part because of new state regulations on the contents and distribution of patent medicines. In their place, carnival operators moved in to bring entertainment to annual holiday celebrations, fairs, and tournaments in small towns. The first documented traveling carnival, the Canton (Ohio) Carnival Company, opened its first show in Chillicothe, Ohio, on May 30, 1899, and it heralded

a continuing relationship between carnival commerce and social service clubs in America's small towns. For the next century, Elks and Moose and Kiwanis clubs raised money for their local charities by sponsoring annual fairs and hiring traveling carnival organizations to bring amusements to vacant lots on the edges of almost every small town in the United States.

One lasting effect of this marriage of economic convenience between carnival operations and civic clubs has been the continual self-policing of the carnival industry. Most carnivals in most towns offered mainly "wholesome" amusements. Full-tilt nudity and gambling, and the gaffing (rigging) of the games—beyond a reasonable limit—might sour the mood of the social club that sponsored the event. Better to take a little from the profit potential this year and get invited back next year. Almost all of the dangers found at the small-town carnival could be traced to the crowd, and not the carnies.

However, there were also carnivals that arranged to play without local sponsorship, but rather with a donation to the local constabulary that allowed a sideshow to run without regulation. And here, the carnival might live up to its dangerous reputation. Its outrageous entertainments, however, came straight from decades of grandiose American showmanship.

By the turn of the century, Wild West shows had expanded their cowboy-and-Indian theatrics with displays of horse riders and "savages" from around the world. Famous battles from recent wars around the globe were reenacted as spectacular performances, and the military riders paraded out daily from the exhibition grounds to traverse the city's streets. Meanwhile, the oddities and ethnographic

Cotton Carnival
Memphis, Tennessee
Marion Post Wolcott
1940

others of the great expositions and circuses were also exhibits in more permanent "dime" museums. "Zip the Pinhead," "Krao, the Missing Link," Francisco Lentini, the "three-legged boy," and hundreds of other freaks migrated between the traveling carnival circuits and appearances in these urban showcases. In New York, another product of the excesses of the Gilded Age was under construction: Coney Island.

SODOM BY THE SEA

The construction of not one, but three, amusement parks on Coney Island transformed this five-mile stretch of beach at the entrance to New York harbor into the world's first modern amusement industry bonanza. When George Cornelius Tilyou opened Steeplechase Park in 1897 a new entertainment business was born, one that continues today with operations such as the Disney and Six Flags amusement parks. Tilyou bought and borrowed what he could from Chicago's Midway Plaisance and other exhibition midways, but he also innovated.

Just to enter Tilyou's boardwalk, the customer had to first pass through the "Barrel of Love," a revolving wooden cylinder designed to knock unsuspecting walkers off their feet and often into the arms of strangers in a reciprocal horizontal embrace. Customers were no longer simply curious onlookers, but agents in their own amusement.

This mode of entertainment expanded through the years, reaching its pinnacle in a pavilion called, by 1940, the "Insanitarium," an onstage funhouse positioned where customers had no choice but to enter as they exited any of several other rides. Here blasts of air would send skirts overhead, and clowns

with gentle electric prods and sometimes less-than-gentle talk kept the lines moving. Once through this ordeal, the customers joined the crowd of onlookers, and their humiliation would usually melt into laughter.

Steeplechase Park was the first of three parks. Luna Park opened in 1903, in a style of architecture that has been called "Oriental Orgasmic": using the same white-painted gypsum plaster featured in the World's Columbian Exposition's Court of Honor, but this time crawling with exotic ornament and covered with hundreds of thousands of lights. Soon after Luna Park's enormously successful opening, a rival park across the street was planned and built: Dreamland Park, with a million electric lights and even larger rides and thrills. By 1905 the quest for the most outrageous entertainment experience had begun, and America's place at the forefront of entertainment technology was firmly established.

Apart from their famous thrill rides—the Ferris wheel, the Helter Skelter, the Tickler, and a progression of ever larger roller coasters and water toboggans—Coney Island's amusement parks staged regular parades of gaudily, and usually scantily, clad dancers. Other popular parades comprised "freaks" and "foreigners," and these spectacles of the erotic and the exotic combined in a visual cocktail unavailable even on the streets of Gotham. However, apart from these occasional viewings, the erotic and the exotic were mostly unavailable in the theme parks of Coney Island. One generally had to seek them outside the parks' walls, in the aging pavilions of the seaside "Gut," where saloons and houses of ill-repute operated as they had since the 1860s.

The amusement parks mounted daily shows that simulated real and imagined events: the eruption of Mount Pelée and the destruction of Martinique, the

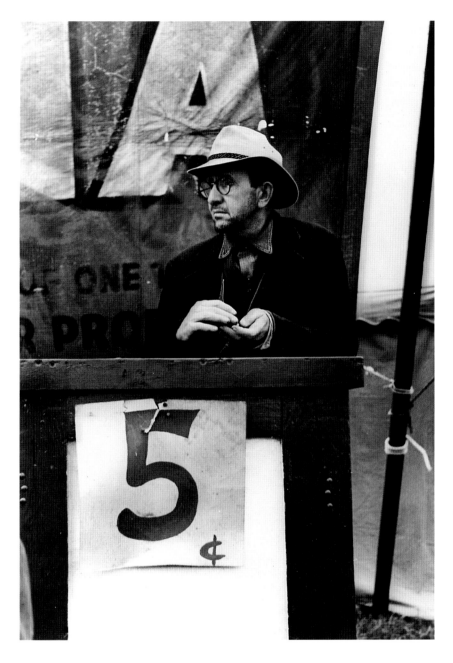

Ticket Seller
Brownsville, Texas
Arthur Rothstein
1942

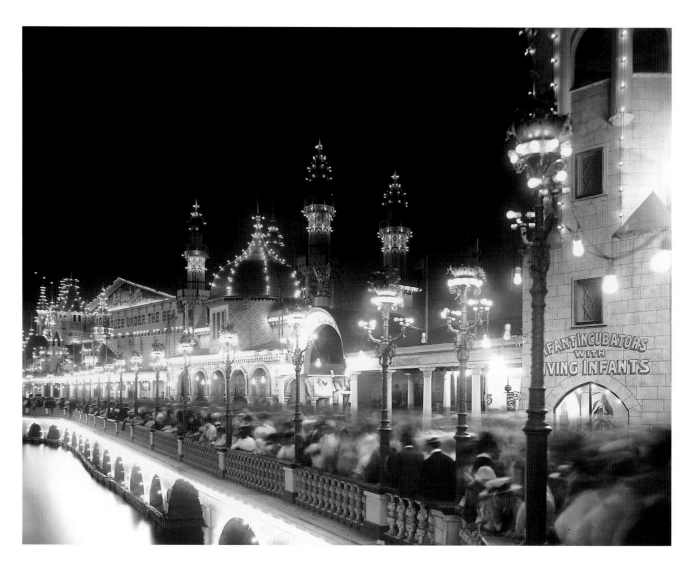

Luna Park at Night
Coney Island, New York
Photographer Unknown
c. 1906

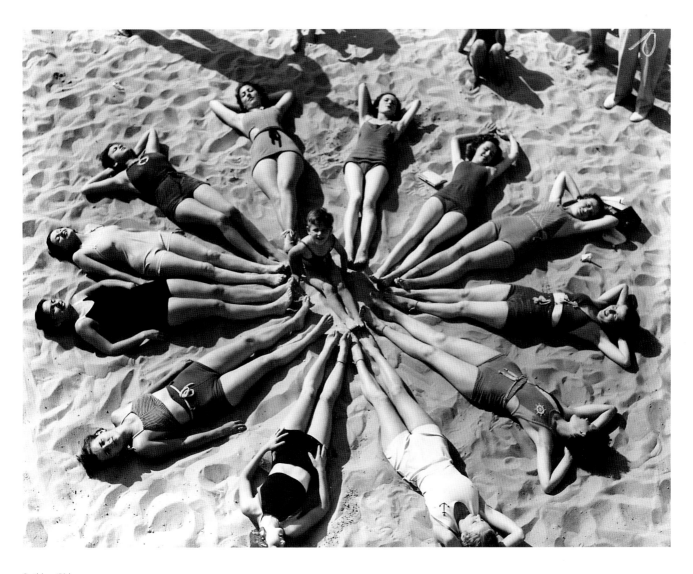

Bathing Girls
Glen Echo Amusement Park, Maryland
Theodor Horydczak
1935

Johnstown Flood, city tenement blocks set ablaze and inhabitants rescued from certain death, and at Luna Park, on Coney Island, even a simulated trip to the moon. As wild as these new amusement zones were, they offered pleasure packaged within legal limits not always in effect in the alleys of the big city. For this reason, the parks were mostly seen by civic leaders as a solution to growing social concerns associated with the vices of sex, alcohol, and gambling, concerns that were amplified by the growing number of employed single women with money and time on their hands.

AMUSEMENT FOR THE OTHER SEX

By the end of the nineteenth century, women were emerging from home-based piecework and sweat shops to fill jobs in newly emerging markets: department stores, public schools, and corporate offices. Women "flocked to these jobs in part because they allowed more free time and autonomy," Kathy Peiss, professor of history at the University of Massachusetts, Amherst, observes. And they used this autonomy for the first time to secure what men had long enjoyed: a separate space for pleasure and leisure. No longer tied to the seventy-hour weeks of piecework at home or elsewhere, thousands of young unmarried women began to frequent the same leisure districts as their brothers and fathers. This trend soon led to new forms of entertainment designed for the female, as well as for mixed audiences.

Before long, savvy park and carnival owners determined that attracting larger numbers of young women also brought in more young men. Variety and vaudeville shows emerged from the erotic fare of the saloons as a cleaned-up, respectable form of

entertainment. By the last decades of the nineteenth century, women in New York had become paying customers for hundreds of dance halls, where social dancing (and more risqué varieties) became a widely accepted form of entertainment. With the extension of public transportation to Coney Island, working women by the thousands were able to frequent this "Sodom by the Sea."

SODOM WILL COME TO CENTERVILLE

The big-city thrills of Coney Island would be copied in many a sea- or lake-side locale, and boardwalks and assorted amusement piers sprang up from Atlantic City to San Diego. These parks offered towering rides along with dancing pavilions, carnival midways, and amusements. But until after World War II, America was still a nation of small towns, and the trip to "see the elephant," that is, to visit one of these leisure meccas, might be a once-in-a-lifetime event. The very next best thing was the annual carnival that showed up down by the railroad tracks one Wednesday in the middle of summer and stayed through the weekend. While the traveling carnival lacked the giant roller coasters of their stationary kin, they offered most everything else. And for most of the century, as all the great amusement parks amused several million customers in a good year, the hundreds of traveling carnivals would amuse ten times that number.

The early 1960s were the peak of the traveling carnival business; they were good economic years, and the pre-teen baby-boom cohort was ripe for the midway. But by the 1970s a high-tide mark was already visible. Some of the amusement piers began to close, and carnival operators had to struggle

against a host of new competing attractions. Rock festival circuits soaked up audiences and cash. Color television, video arcades, and the spectacles offered by Hollywood movies gave customers alternatives to venturing out to the carnival. Subtle cultural shifts away from civic entertainments to personal or outdoor leisure activities sapped the popularity of carnival amusements. On the production side, television and film offered entertainers money and exposure unavailable through the carnival circuit. While even a small ride might still pack a powerful thrill, once the consumer had seen the world's best acrobats, singers, and dancers on *The Ed Sullivan Show*, the talent that was left for the carnival could not attract a crowd to meet its own payroll. The carnival lost its performers and became a business solely of rides and games.

By 1999, the first century of the American carnival had come to its end, and we are still looking to measure its effect on American life. In some ways, the traveling carnival persists as an anachronism. Gaudy and mechanical, crowd-oriented and labor-intensive, it argues against everything that the digital revolution might soon change. Already, video arcades offer virtual-reality roller coasters and sideshow-like games. And computers and the Internet take up even more of our leisure time.

As with many things that have been around for a long time, we think we know about the carnival without ever having taken a second look. But then we've been suckers before, and the American traveling carnival might have a few surprises left in its reptile tent.

Lion's Cage at Champlain Valley Expo
Essex Junction, Vermont
Jack Delano
1941

References:
Csida, Joseph, and June Bundy Csida. *American Entertainment: A Unique History of Popular Show Business*. New York: Watson-Guptill Publications, 1978.
Kasson, John F. *Amusing the Million: Coney Island at the Turn of the Century*. New York: Hill & Wang, 1978.
McKennon, Joe. *A Pictorial History of the American Carnival. Vol. 1*. Bowling Green, Ohio: Popular Press, 1971.
Peiss, Kathy. *Cheap Amusements: Working Women and Leisure in Turn-of-the-Century New York*. Philadelphia: Temple University Press, 1966.
Pilat, Oliver, and Jo Ranson. *Sodom by the Sea: An Affectionate History of Coney Island*. New York: Doubleday, Doran & Company, Inc, 1941.

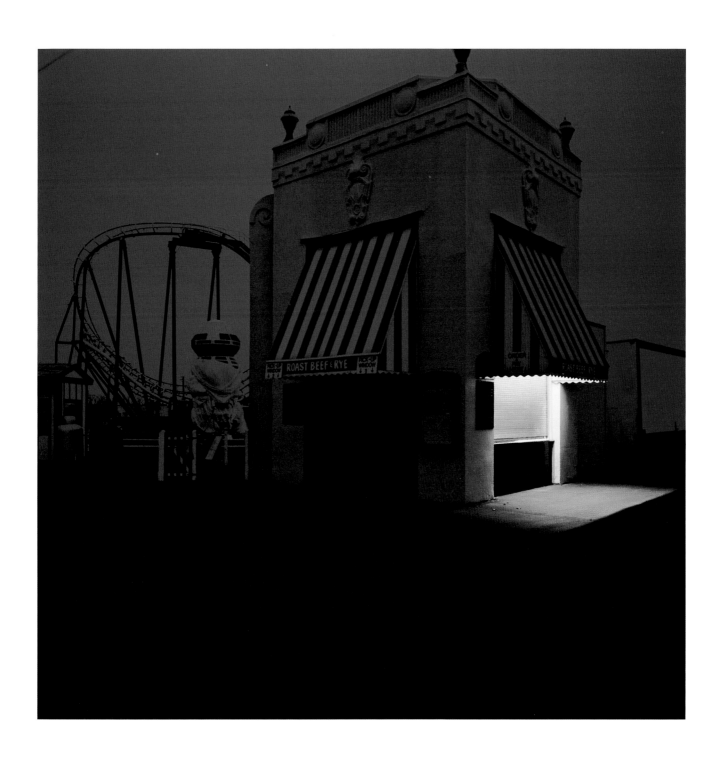

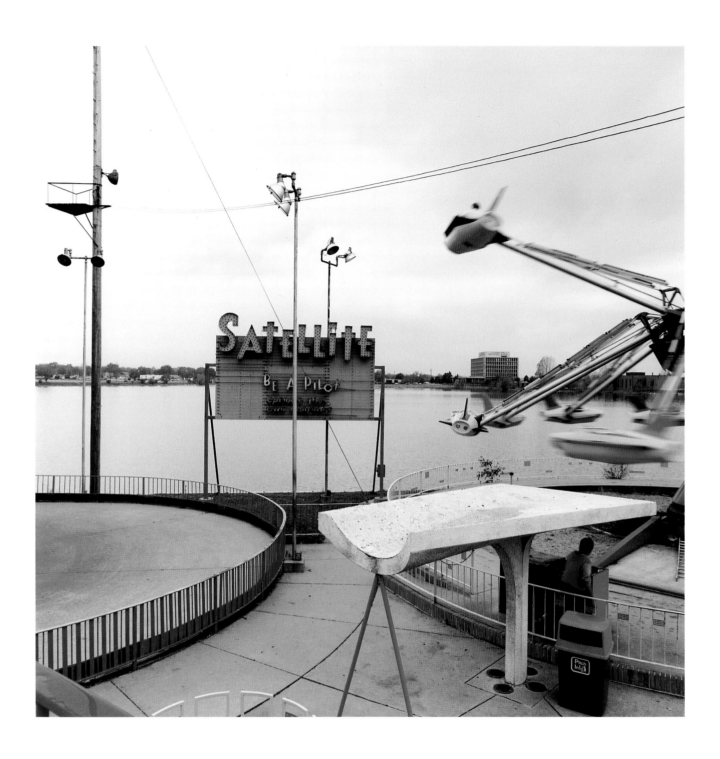

SATELLITE / Denver, Colorado 1990

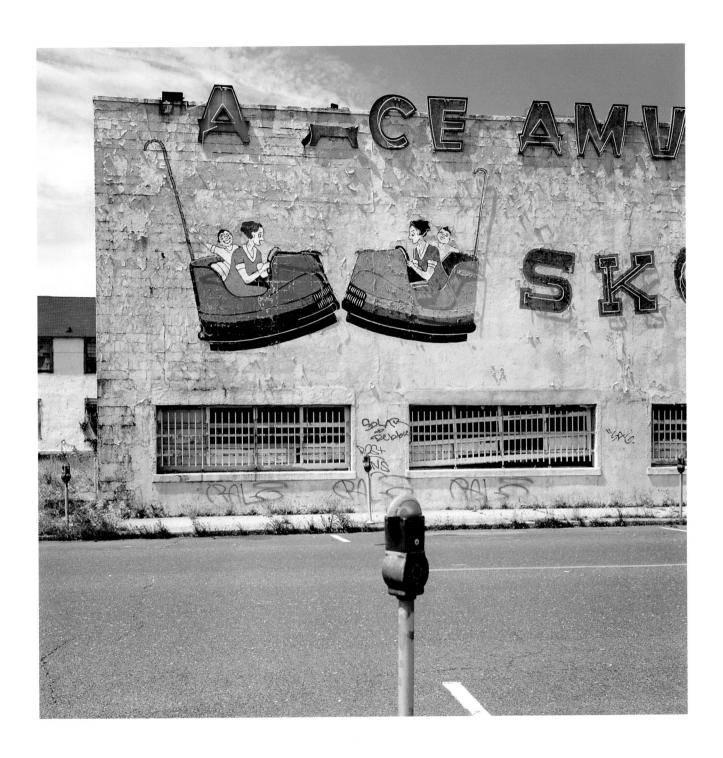

BUMPER CARS #1 / Asbury Park, New Jersey 1998

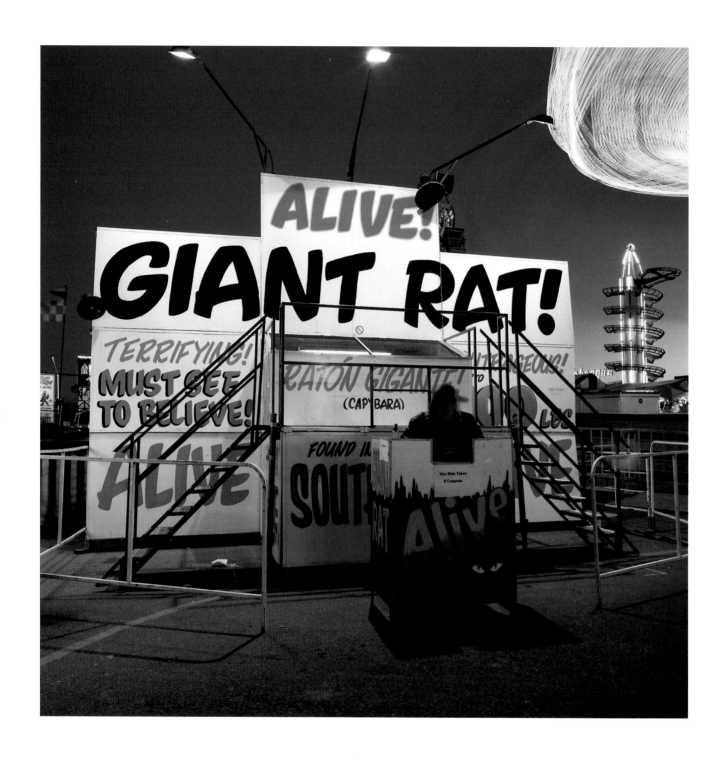

GIANT RAT / Ventura, California 1987

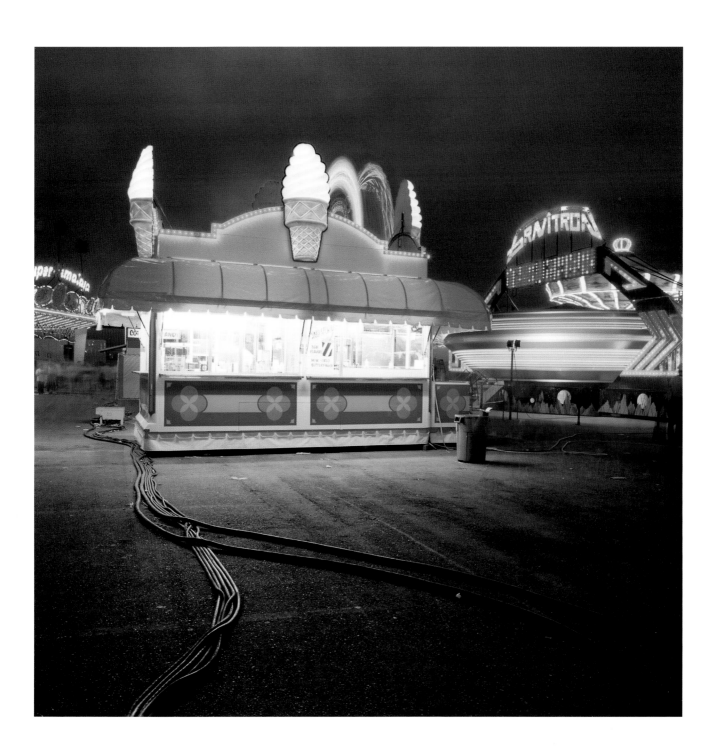

ICE CREAM BOOTH / Ventura, California 1988

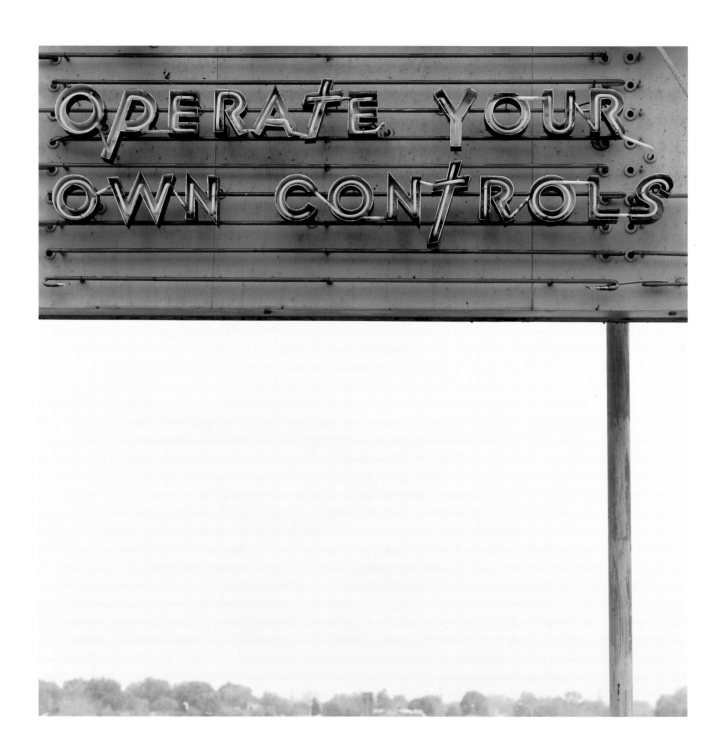

30 OPERATE YOUR OWN CONTROLS / Denver, Colorado 1990

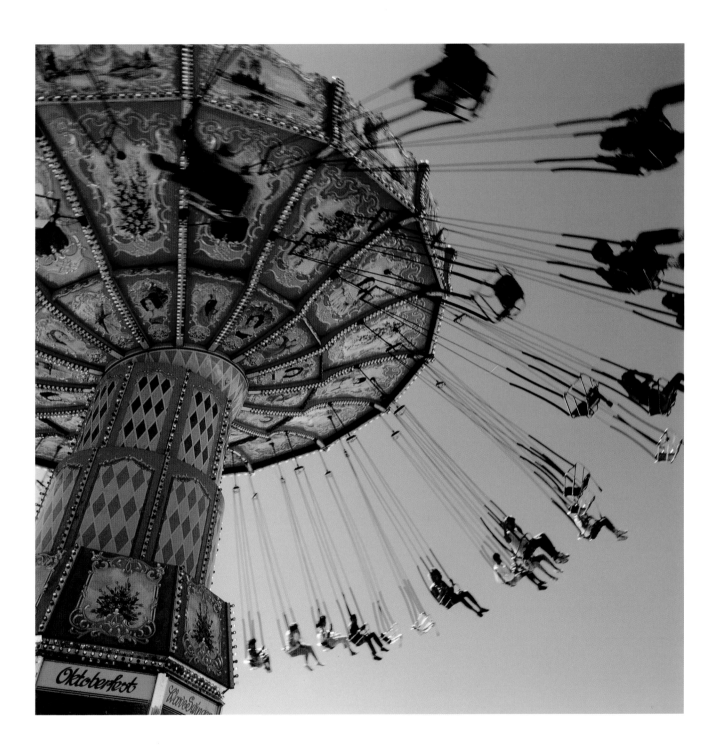

WAVESWINGER / Ventura, California 1987

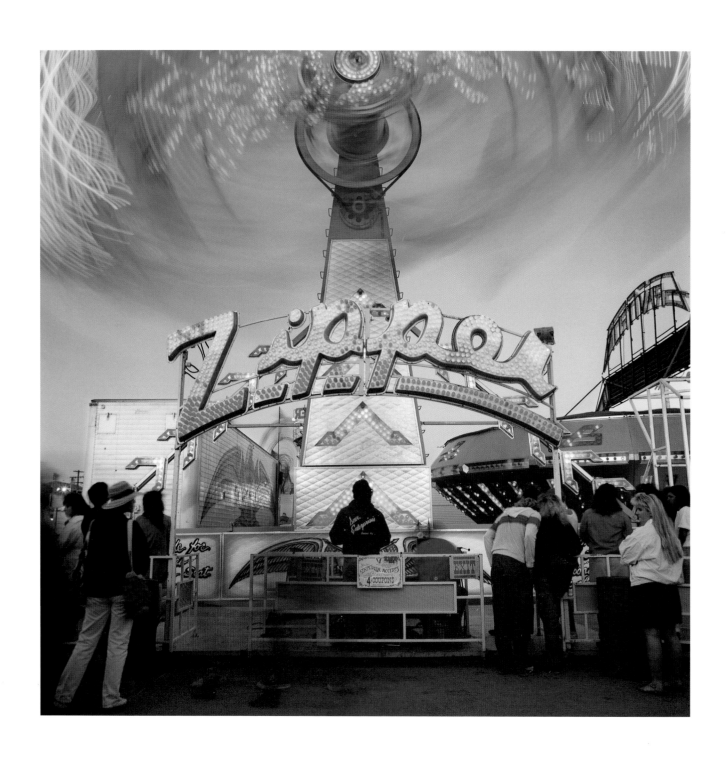

ZIPPER / Ventura, California 1987

ROCK-O-PLANE / Denver, Colorado 1990

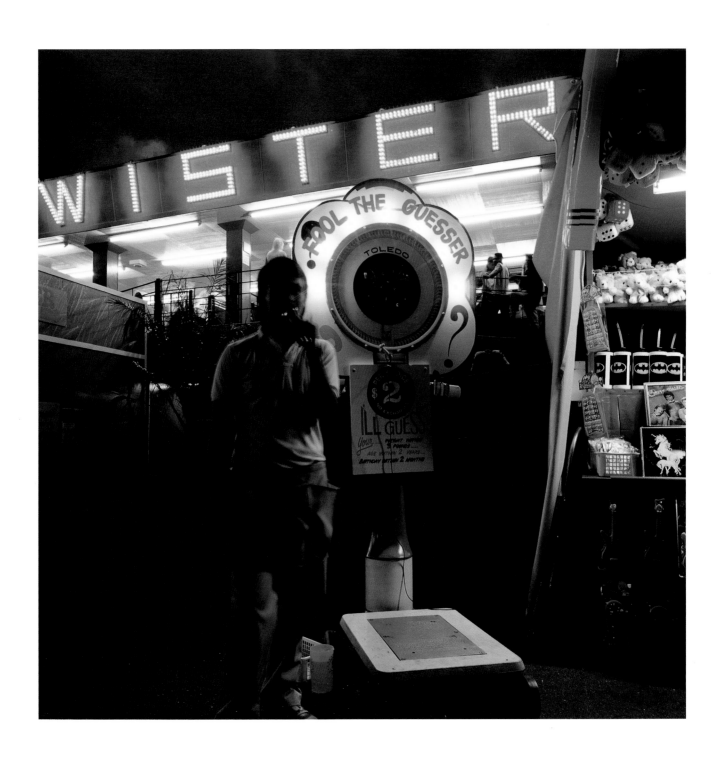

FOOL THE GUESSER / Denver, Colorado 1990

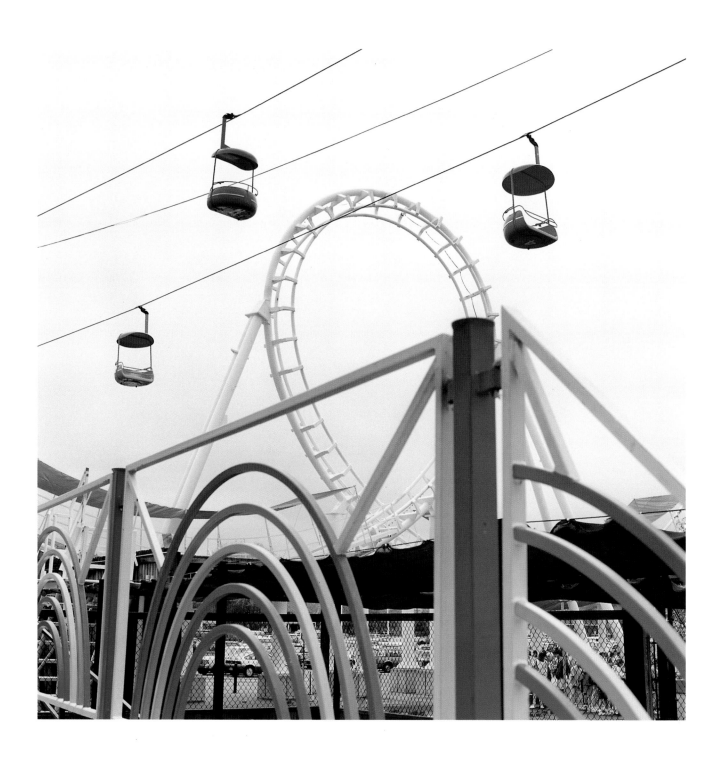

SKYWAY / Denver, Colorado 1990

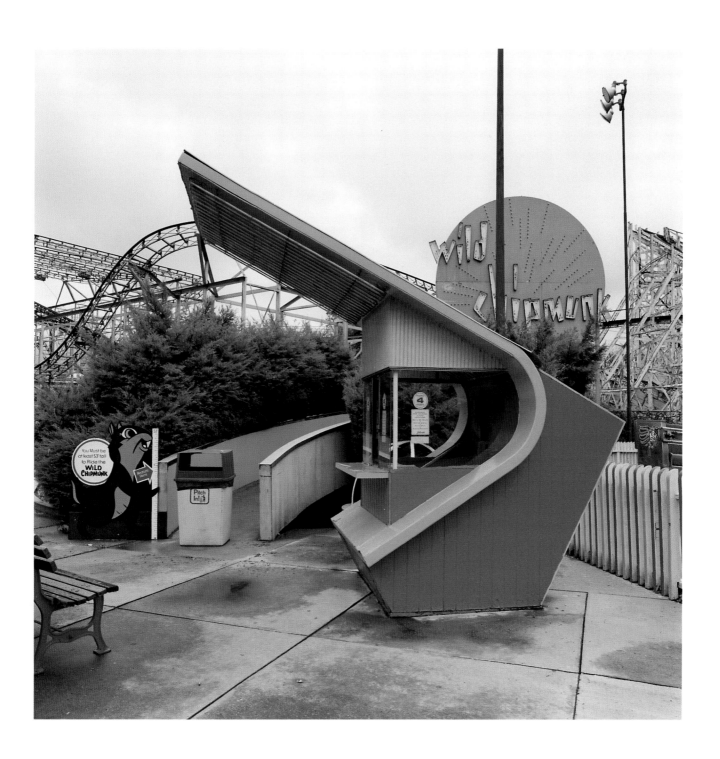

WILD CHIPMUNK / Denver, Colorado 1990

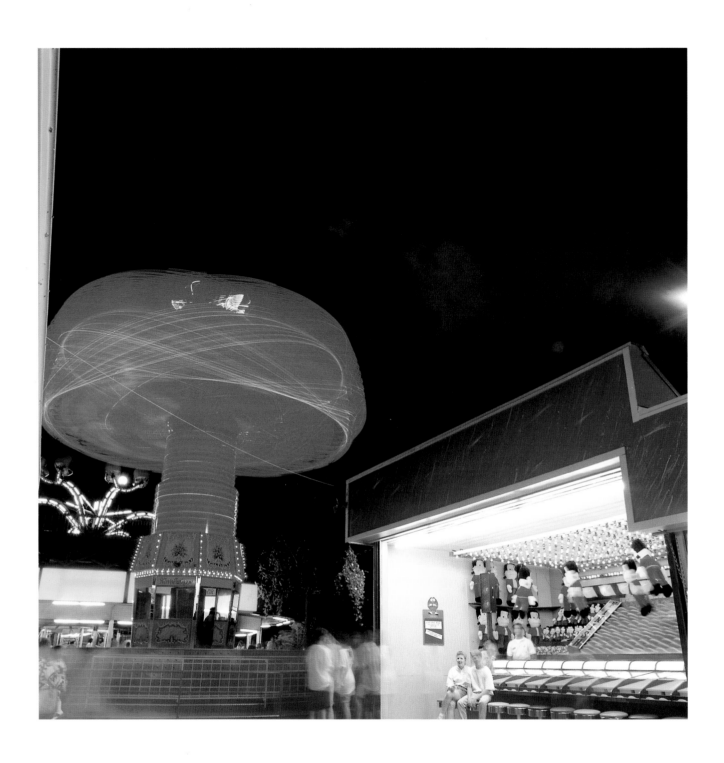

38 WAVESWINGER (NIGHT) / Denver, Colorado 1990

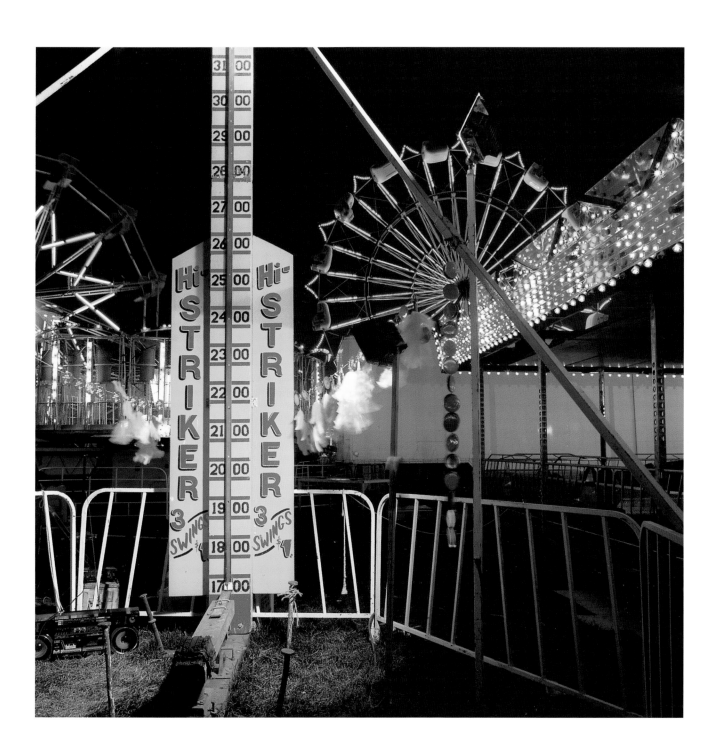

HI-STRIKER / Santa Maria, California 1989

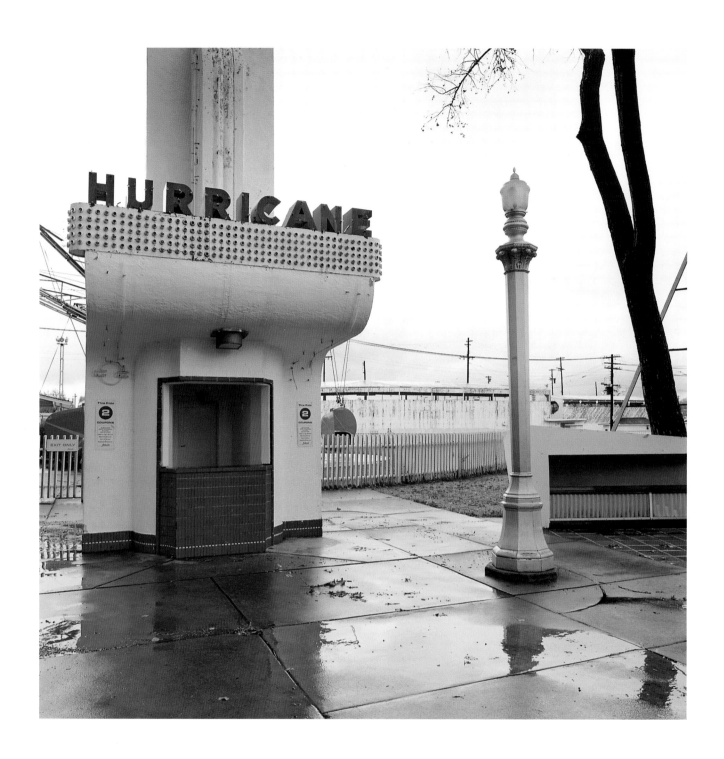

HURRICANE / Denver, Colorado 1990

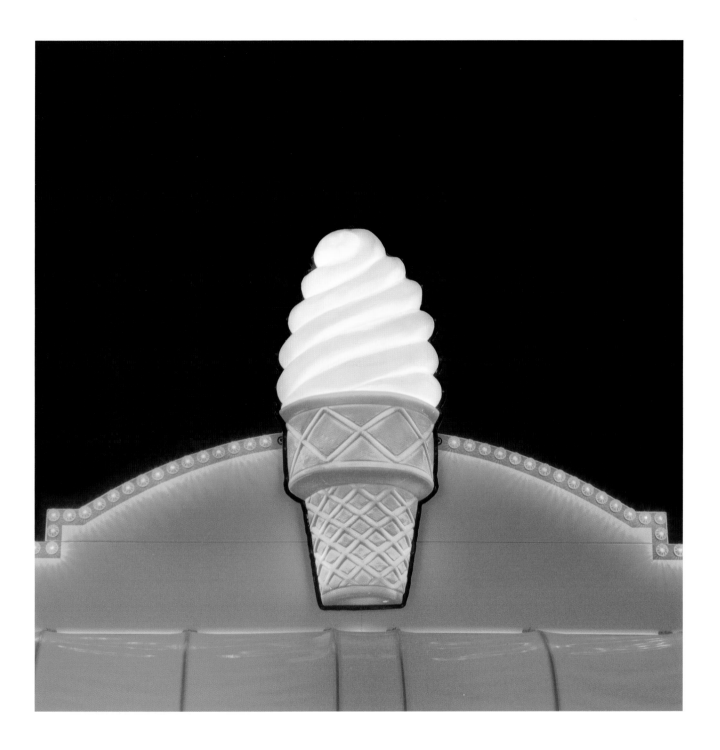

ICE CREAM CONE / Ventura, California 1988

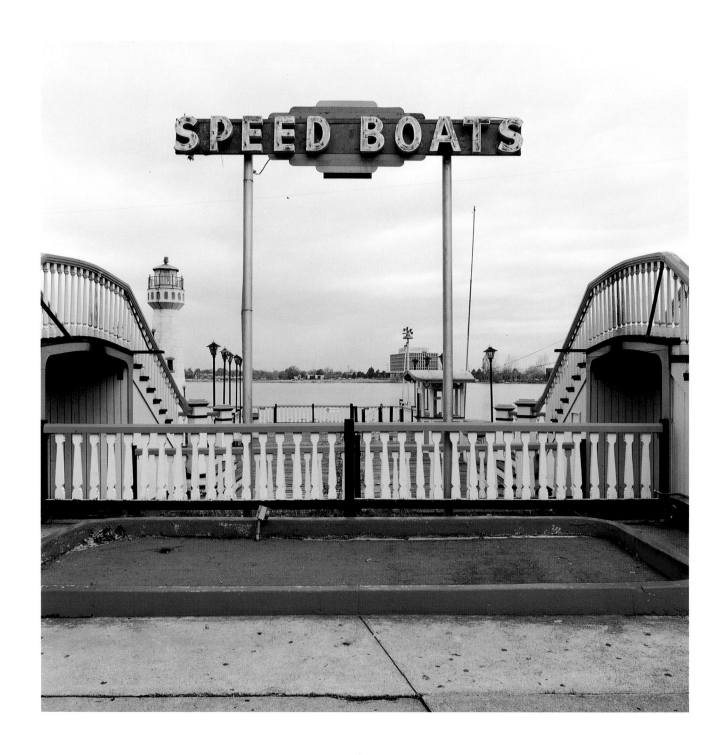

SPEED BOATS / Denver, Colorado 1990

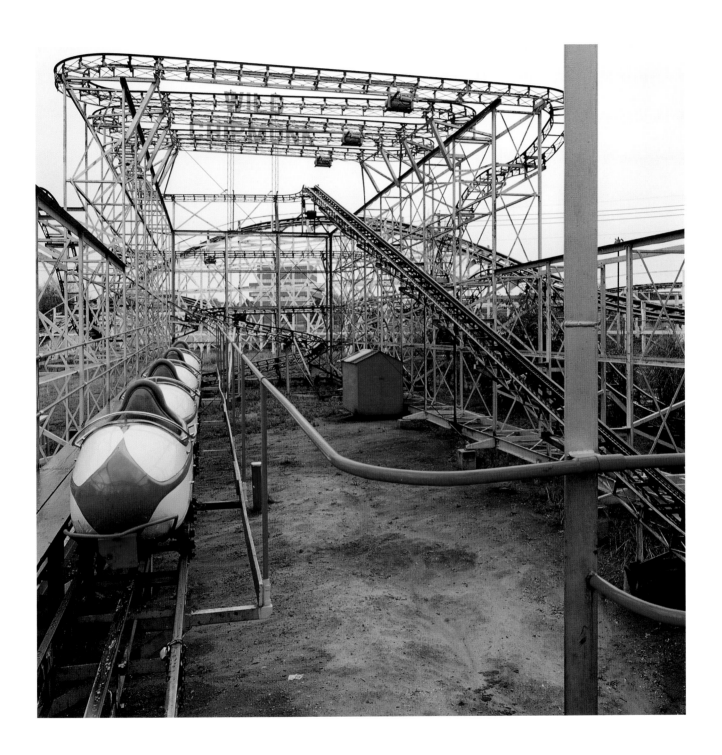

WILD CHIPMUNK #2 / Denver, Colorado 1990

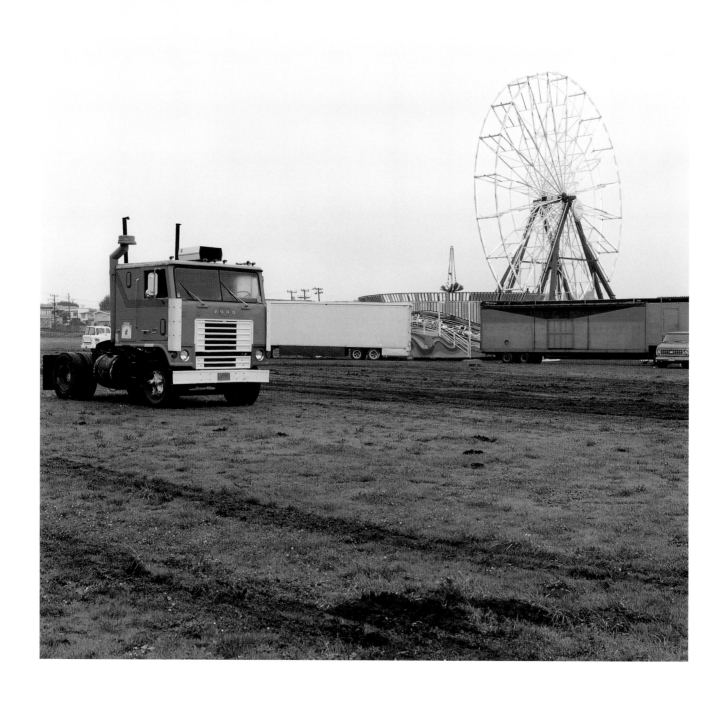

CARNIVAL #1 / Daly City, California 1991

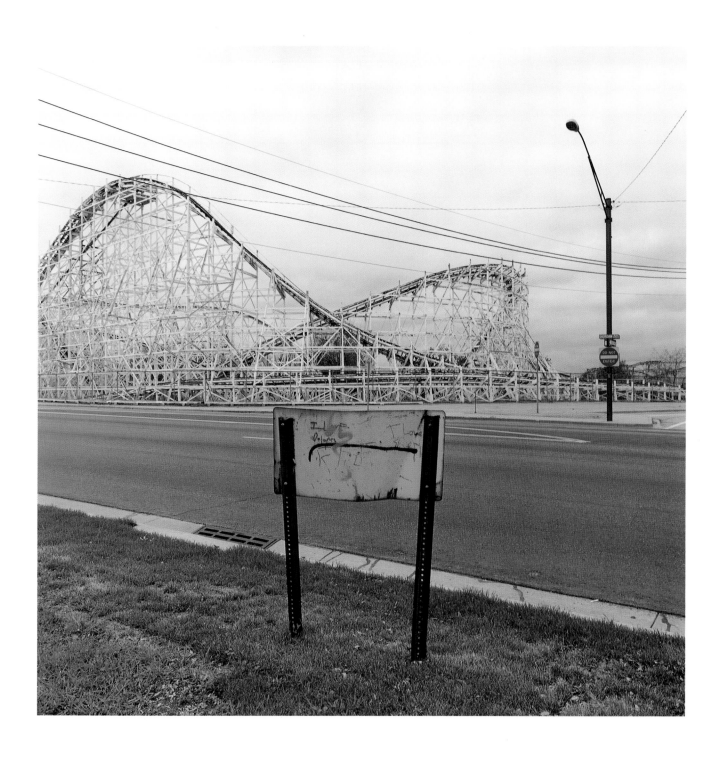

CYCLONE #1 / Denver, Colorado 1990

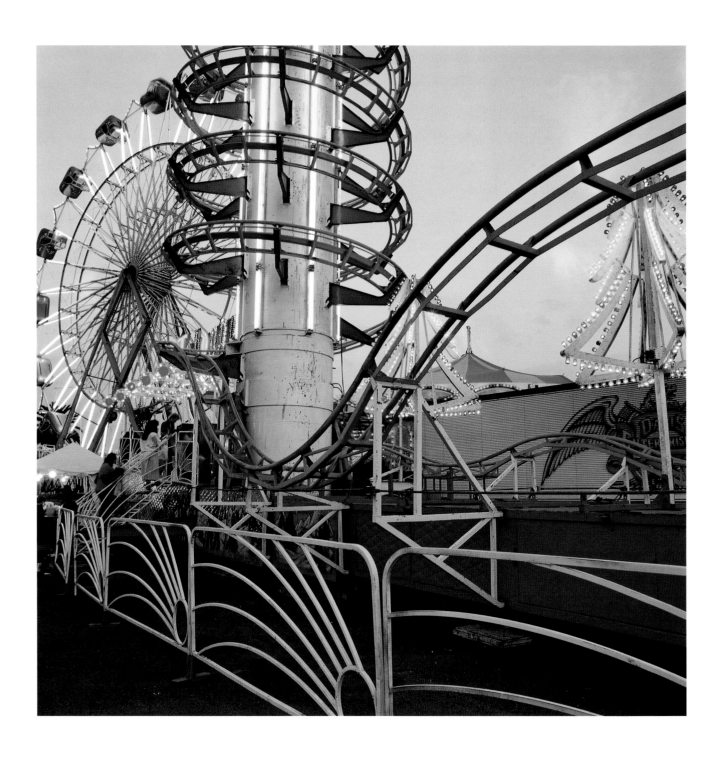

TOBOGGAN / Ventura, California 1989

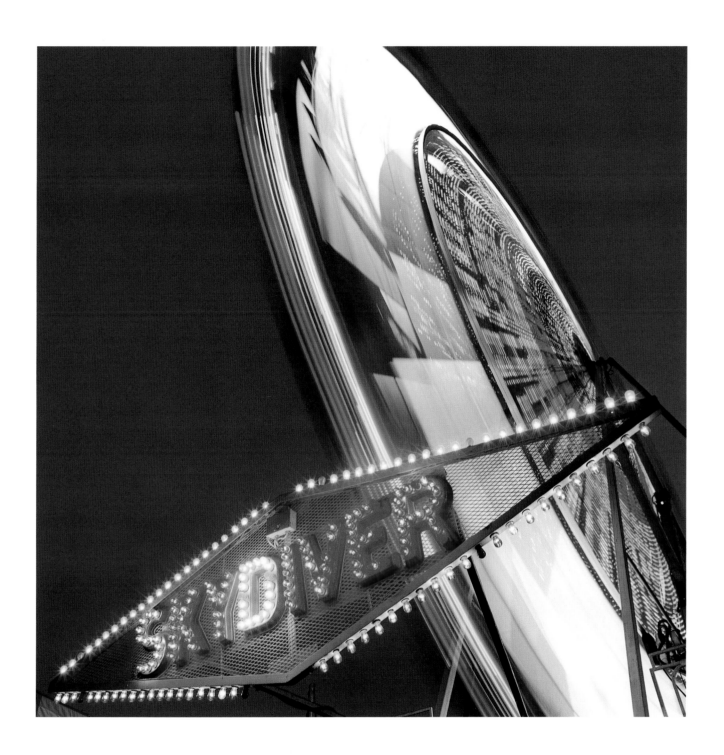

SKYDIVER / Ventura, California 1989 47

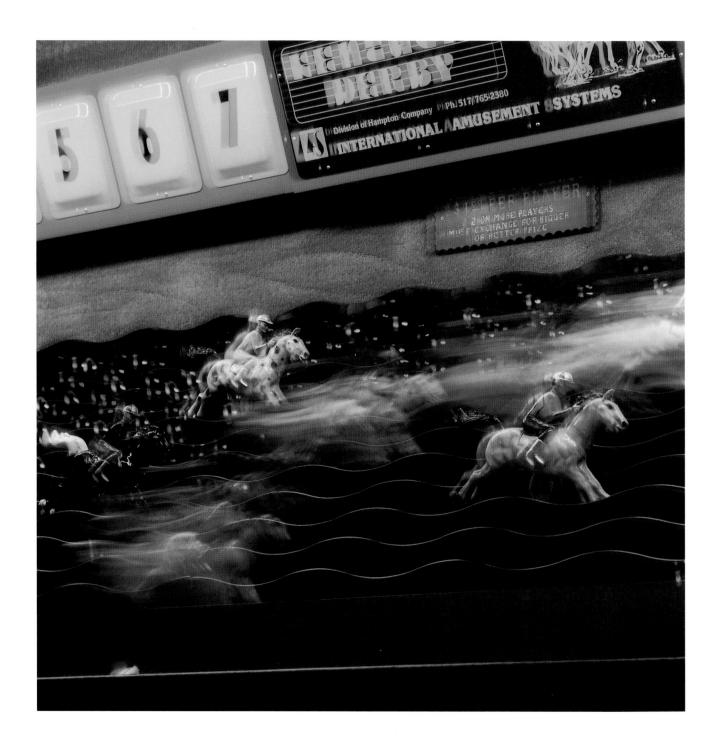

DERBY / Santa Barbara, California 1988

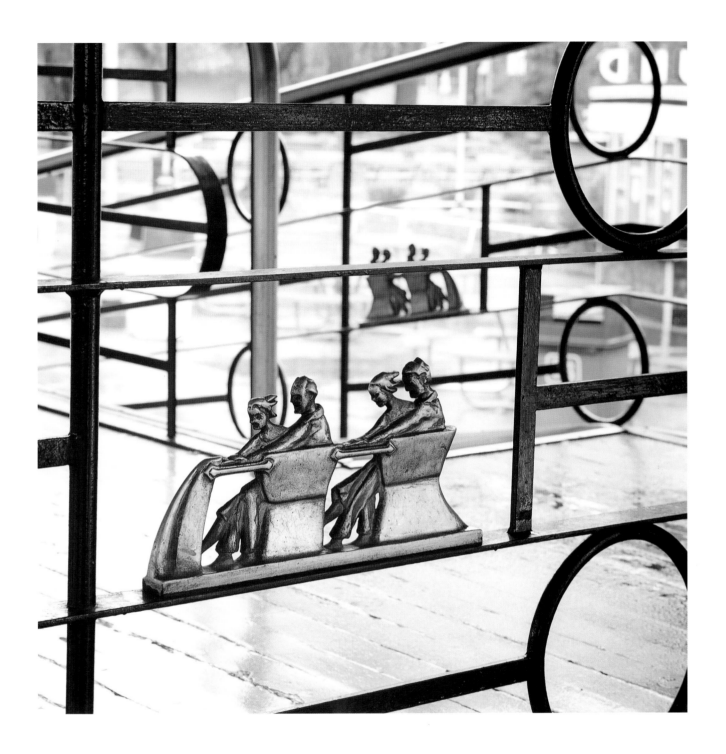

CYCLONE (DETAIL) / Denver, Colorado 1990 49

PAINT / Santa Maria, California 1989

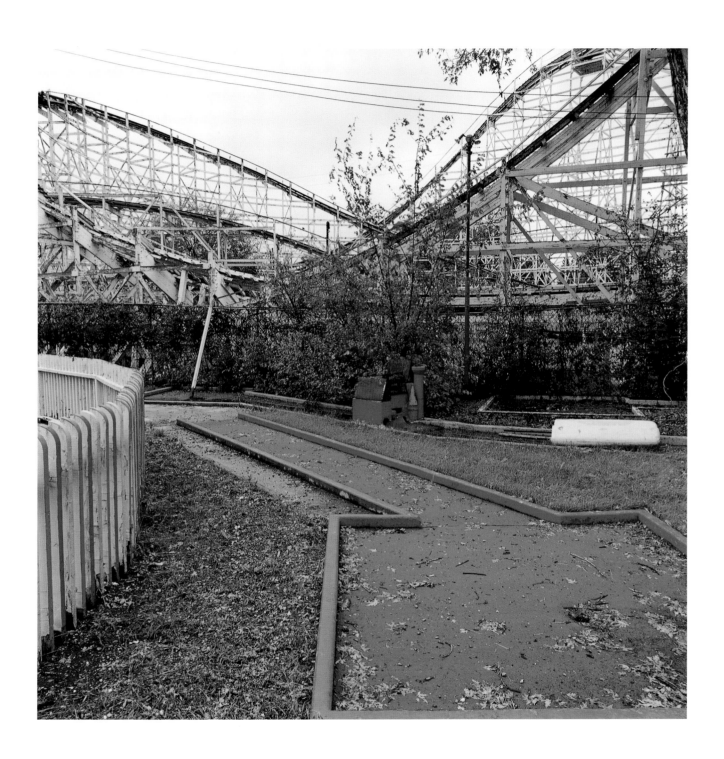

MINIATURE GOLF / Denver, Colorado 1990

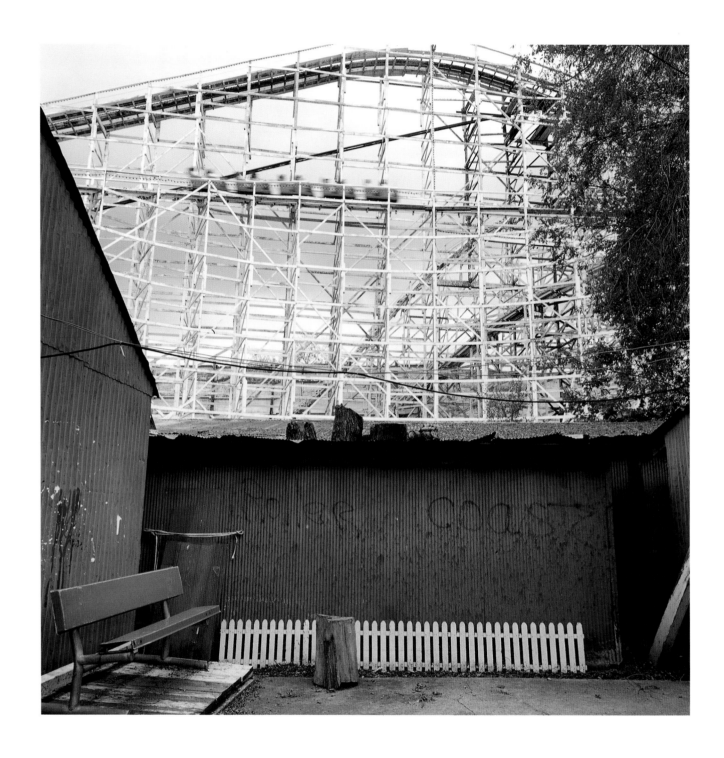

ROLLER COASTER (PICKET FENCE) / Denver, Colorado 1990

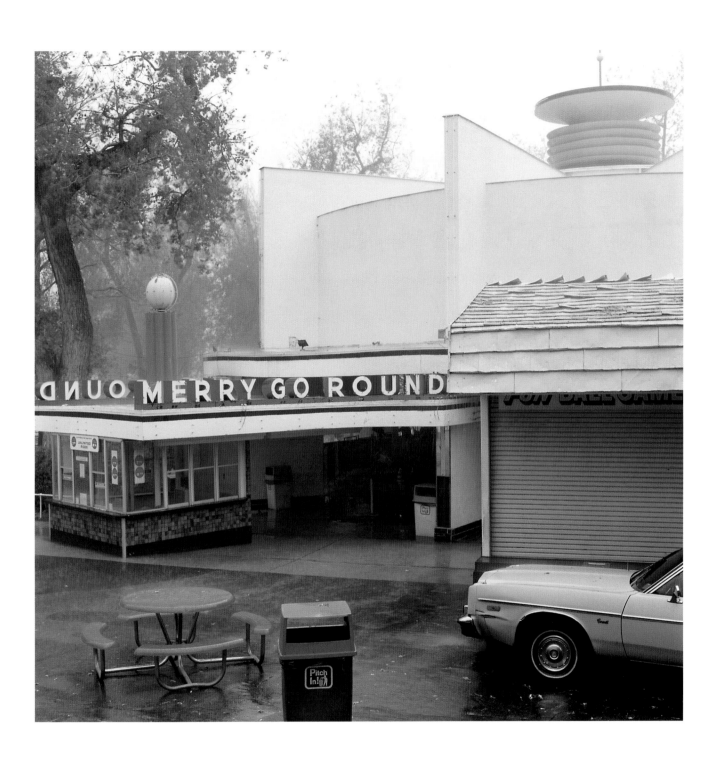

MERRY GO ROUND / Denver, Colorado 1990

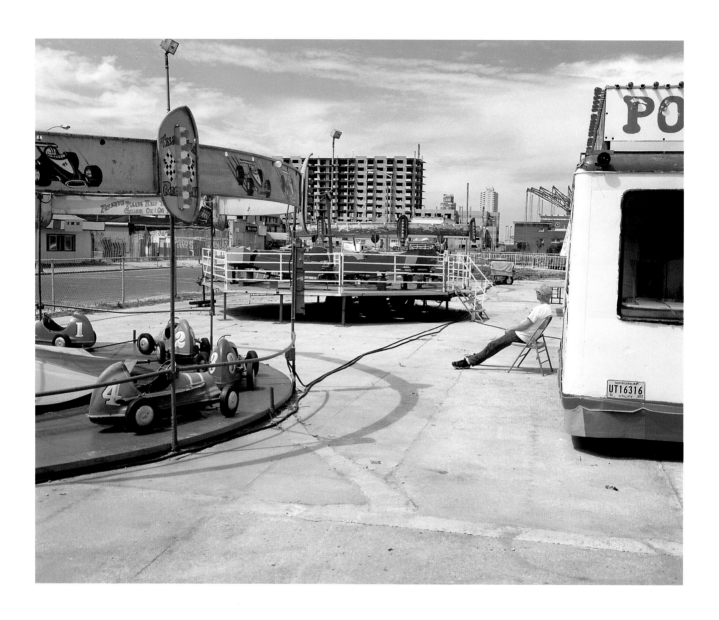

CARNY, RACE CARS / Asbury Park, New Jersey 1998

ABANDONED MINIATURE GOLF / Asbury Park, New Jersey 1998 55

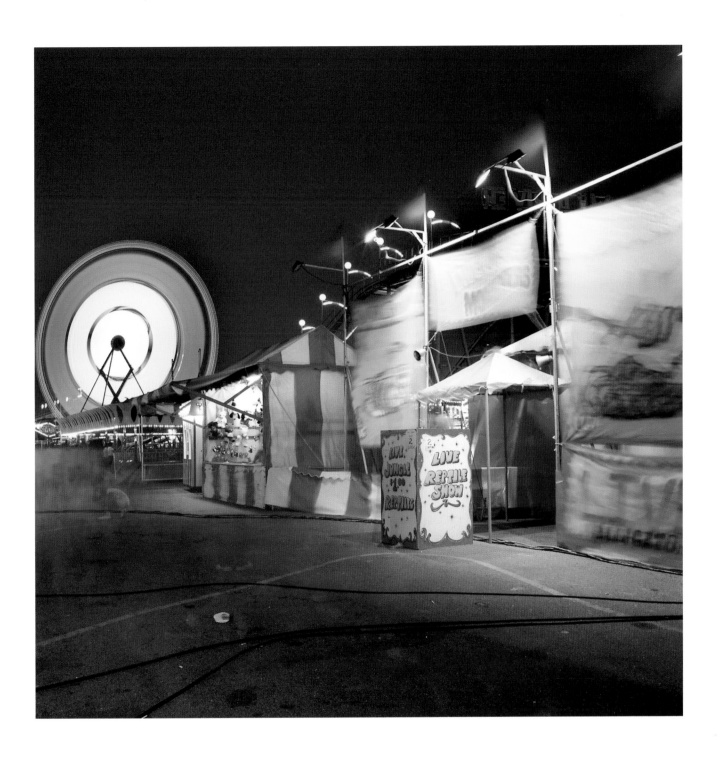

LIVE REPTILE TENT / Ventura, California 1987

COASTER AND CLOUDS / Denver, Colorado 1990

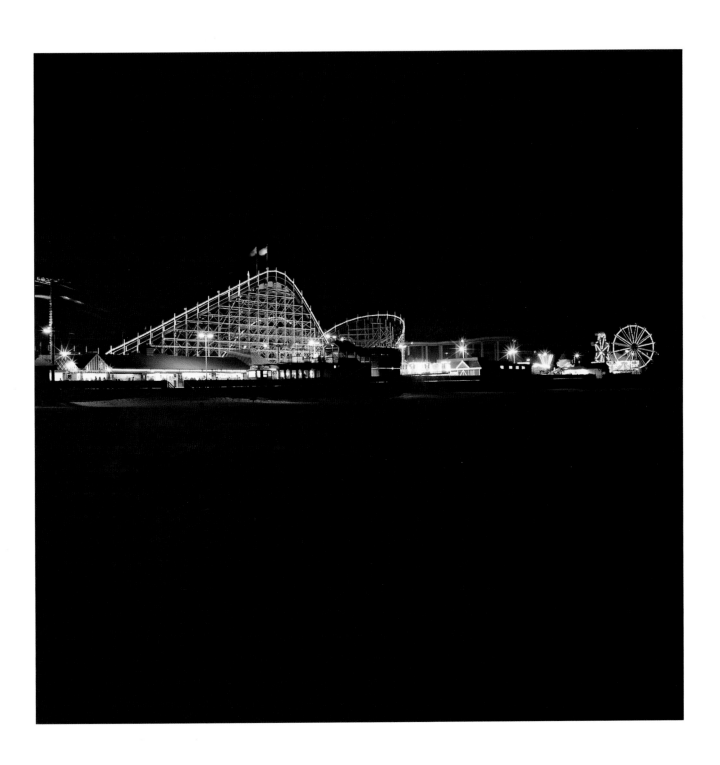

BOARDWALK AT NIGHT / Santa Cruz, California 1991

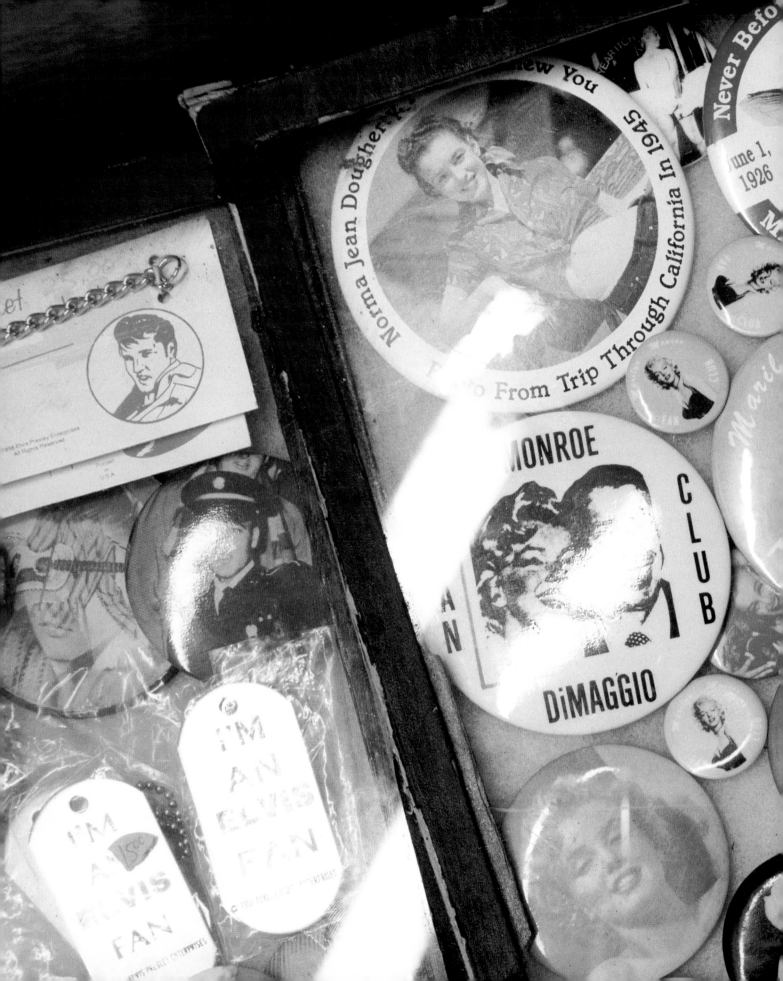

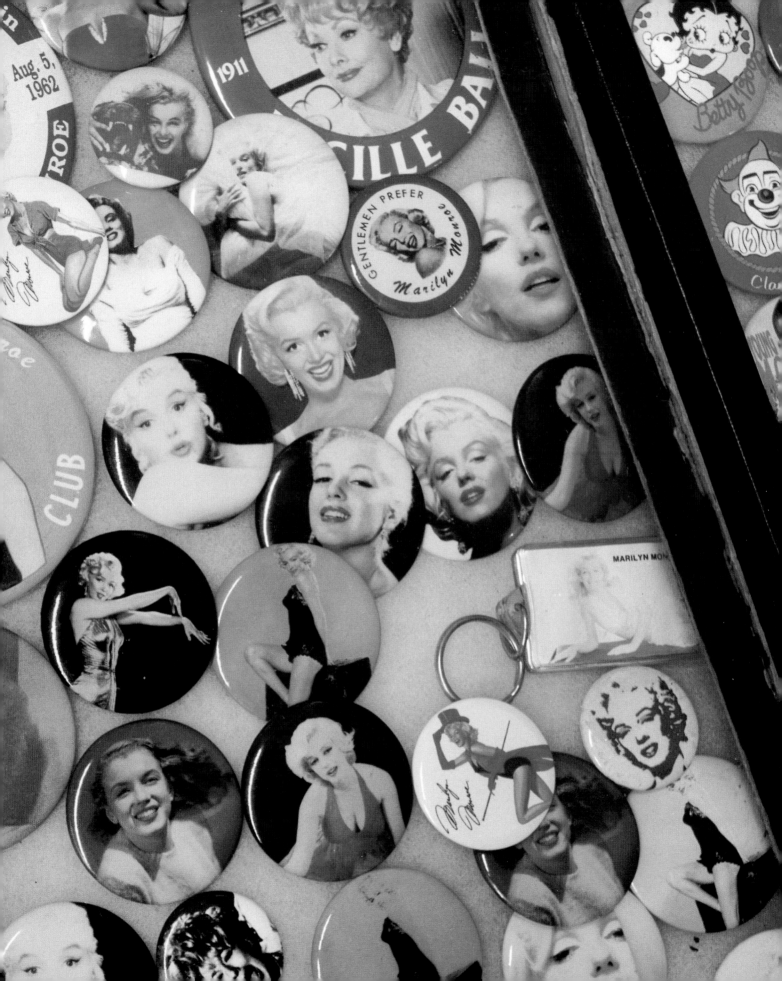

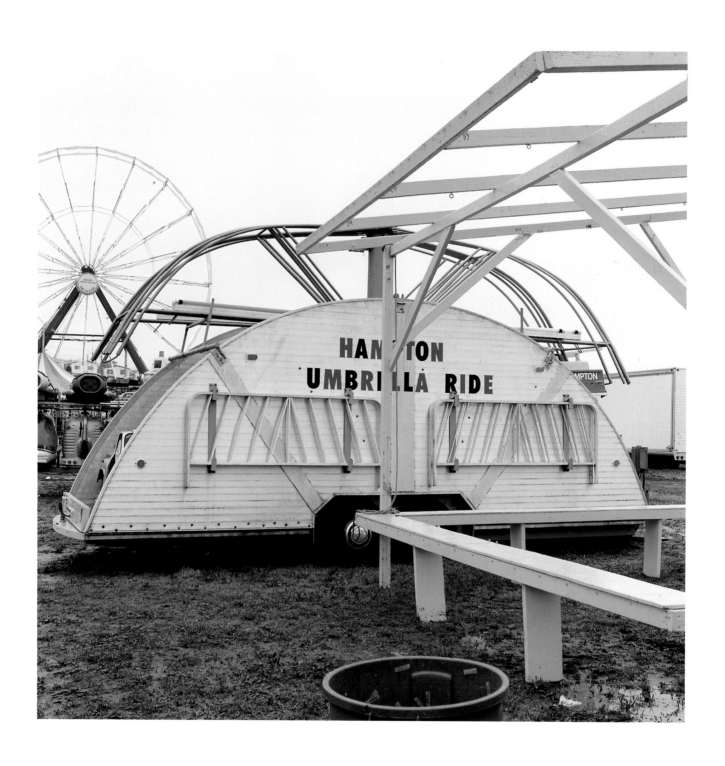

UMBRELLA RIDE / Daly City, California 1991

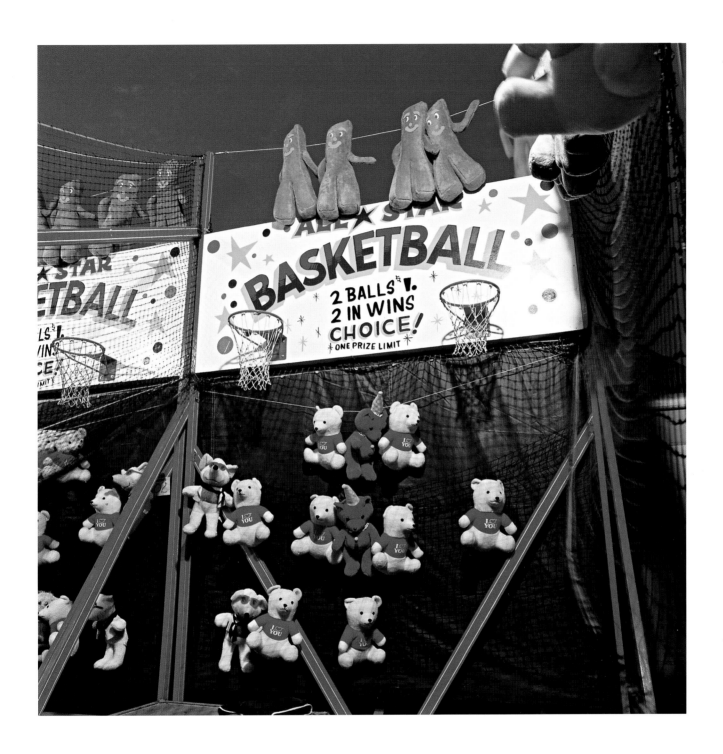

GUMBY BASKETBALL / Ventura, California 1988

DARTS / Ventura, California 1987

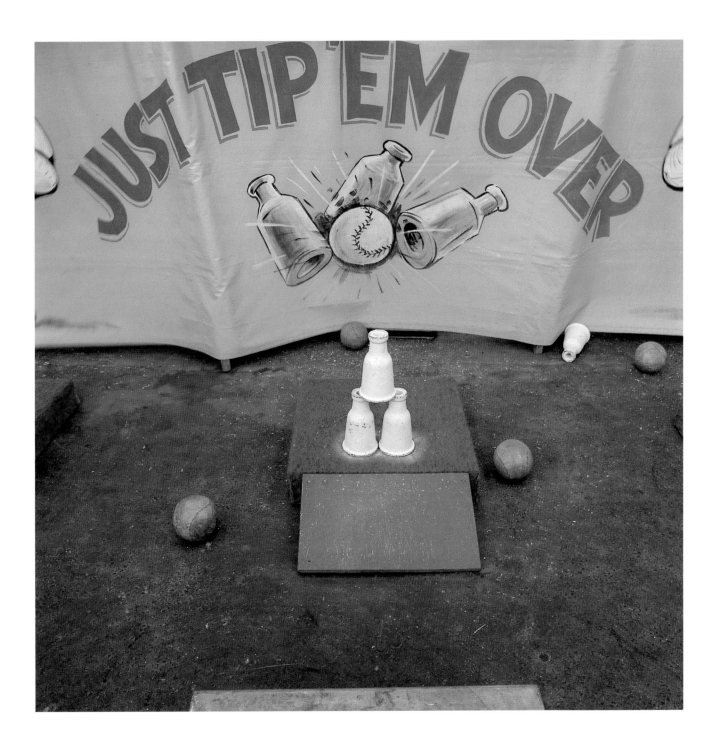

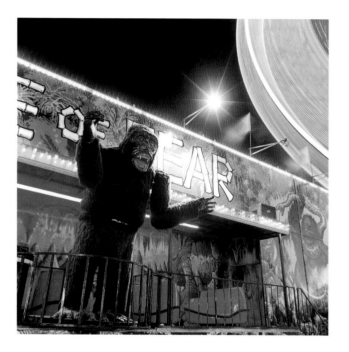

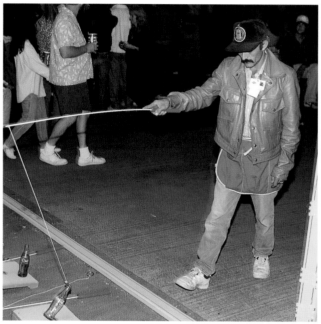

JUNGLE OF FEAR / Ventura, California 1990 CARNY WITH POLE / Ventura, California 1993

 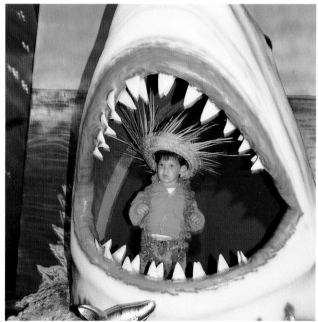

CONES / Ventura, California 1989 JAWS / Ventura, California 1993 67

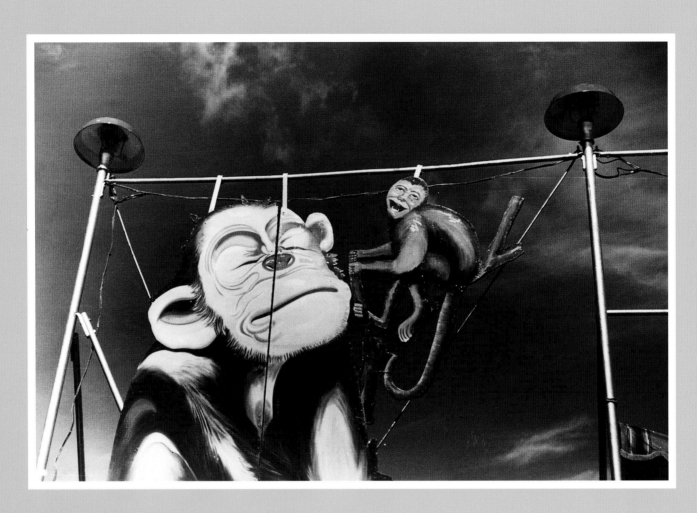

Decorations at a Sideshow
Rutland, Vermont
Jack Delano
1941

THE POLITICS OF LAUGHTER

The notion of escaping a dull, meaningless lifestyle by joining the carnival or the circus has long served as a metaphor for the distance between "real life" and the fantasy of a life of travel and adventure, one we can always turn to when everything else turns against us.

Lately, however, this metaphor has been dislodged by other dreams: winning the lottery, say, or amassing a fortune on a high-tech stock flier. In the earlier dreams laughter made up for the lack of cash. But even these new dreams seek to build a bridge between the Kansas of our current predicament and some distant Oz.

Like Buddhists (albeit bourgeois ones), we sometimes dread the world around us and long for an obscure satori, for a nirvana filled with everything we now lack and lacking nothing we might want.

But like Zen Buddhists, we might also suspect that it is only our metaphor of distance that traps us in Kansas and hides an Oz that already surrounds us— and that we need only open our eyes to this to make it so. And once our curiosity is aroused, we might begin to ask some fairly important questions: How did this misinformed metaphor come to be? How did the world of the "serious" and a life of fun and laughter become mutually divorced from each other? Why did anyone allow this to happen? And how do we get out of Kansas?

Elsewhere, I make the argument that the American traveling carnival is as modern as the American factory production line. Here I want to show that the carnival is not a trivial cultural anomaly, and not simply a sideshow to "more serious" cultural practices. First we need to rethink the idea of cultural "importance."

Allon White has identified the misidentification of seriousness with importance as the most fundamental oppression practiced by modern cultural institutions. With other cultural historians, he has begun to track the history of the above metaphor. Somehow, in the eighteenth-century divorce between mundane life and the carnival world, the former, which already had a monopoly on seriousness (something the carnival could care less about), was also given custody of importance—as if seriousness implied the importance, while there is, in White's estimation, "no intrinsic link at all" between them. The result is what White calls the "social reproduction of seriousness." This practice promotes the "ruse of reason" that underlies the fiction that we cannot be in Oz and Kansas at the same time. This ruse is useful in creating a "high culture" of arts and letters under the control of "important" cultural institutions.

The purveyors of "serious culture," churches, museums, and universities, would allow the carnival midway a cultural place where nothing of importance can happen, a space for trivial play only. At best, they view it as a harmless waste of time; at worst, a nagging distraction from "real culture." I would respond that the modern American traveling carnival is connected to a long historical stream of cultural practices, practices older than any university, perhaps older than any current religion, practices tied to an important cultural logic that can be called the "carnivalesque."

The carnivalesque is as much a mood as it is a moment. It is an itch, a tickle, a sly wink at the rest of life. Most forms of comedy tap directly into this pool of whimsy. For the Czech writer Milan Kundera, the carnivalesque is the "unbearable lightness" that life and writing must, at all cost, cling to. For the anthropologist Victor Turner, it is life transformed from the indicative to the subjunctive mood, where all things possible can become visible. The Russian cultural theorist Mikhail Bakhtin claims that we have lost the medieval carnival spirit and with it, an entire other mode of life. But perhaps he counted too much on the claims of modernists who figured that science and reason would, sooner or later, leave nothing to laughter. He also notes the oppressive power of authorized seriousness in modern times, and he looks for ways to reverse the arbitrary equation of importance with tragedy. Most of all, Bakhtin searches for a serious way of laughing.

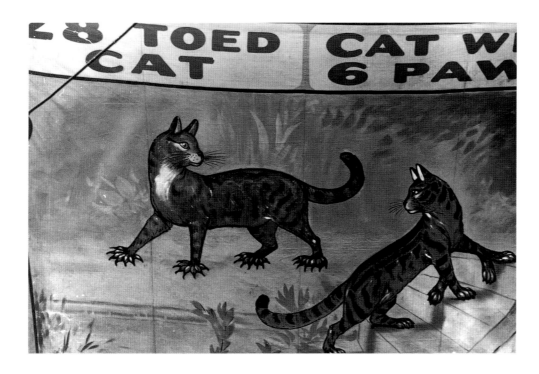

Poster Advertising Sideshow
Rutland, Vermont
Jack Delano
1941

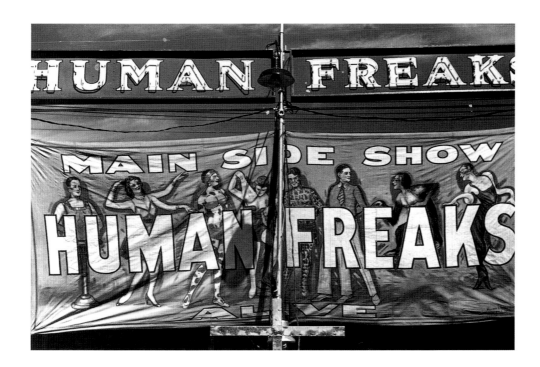

Poster Advertising Sideshow
Rutland, Vermont
Jack Delano
1941

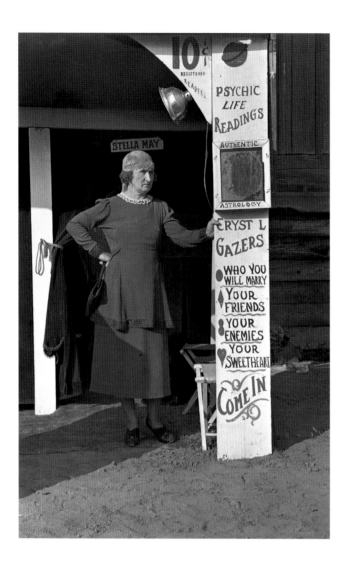

Fortune Teller, State Fair
Donaldsonville, Louisiana
Russell Lee
1938

Laughter is the hallmark of the carnivalesque. Bakhtin notes that medieval festivals often started with the selection of a king or queen for laughter (*roi pour rire*), who would command that laughter be the order of the day. He also describes medieval times as a life-way where work and festival calendars balanced each other, and where the regularity of carnival events allowed laughter to leaven the work days. "Thus carnival is the people's second life, organized on the basis of laughter," he observes. "It is a festive life. Festivity is a peculiar quality of all comic rituals and spectacles of the Middle Ages."

The king of the carnival was also its clown, and this reversal of position was a large part of the joke. Putting laughter above seriousness, above the solemnity of religion and the dignity of royalty, upset all propriety. So, too, the carnival elevated the lowly. Women, the young, and the poor found arenas in which to challenge domination. Civic leaders might be required to dress as women for the day. The motley costumes of the clowns also signaled the collapse of class stature in a time when social privilege was marked by one's attire.

The regular, if only temporary, reversal of privilege made the lack of the same endurable. But this reversal was only the opening stanza for the carnival. The term "carnival" (literally "to raise the flesh") as its Latin origin implies, marks a time when the body is raised to and by its own appetites. Carnivals are times of excess. They are occasions for feasting, drunkenness, dancing, sex—as much as the body can stand, and occasionally more than that. Festivals and fairs are commonplace elements in

European history, and in its prose as far back as Chaucer and Rabelais. Earlier legends of Roman Saturnalias still echo through the literature. Medieval commentators noted that a surplus of new babies could reasonably be predicted after certain of the church's more enthusiastic festivals. This legacy of festivity only recently diminished. Workers in England celebrated "Saint Monday" until the middle of the nineteenth century by remaining at home to recover from the excesses of Sunday. And Sunday itself was long the day of the week when the popular passion for medieval games (such as Morris dancing, maypoles, and bear baiting) and other amusements kept the carnival spirit alive, until most Sunday sports were outlawed in England more than two hundred years ago.

TO SAMBA OR NOT TO SAMBA

Certainly, the lack of modern-day monarchies makes imperial role reversal less interesting than back in the days when the real king's men could execute you for laughing out of turn. Forcing the local mayor to dress as, say, a fast-food restaurant worker for a day would merit scarcely a good chuckle. And lampooning our democratic leaders is often made far too easy by their own undignified behavior. Still, carnival's modern urban festival representations, from Rio to New Orleans, strive to keep the party hardy at a time when insurance companies and government cultural ministries work in concert to hold back the carnival impulse. But the question still lingers: have we, as Bakhtin claims, lost the carnival logic in our lives? And if so, is this the price we must pay for other lifestyle choices? Let's examine

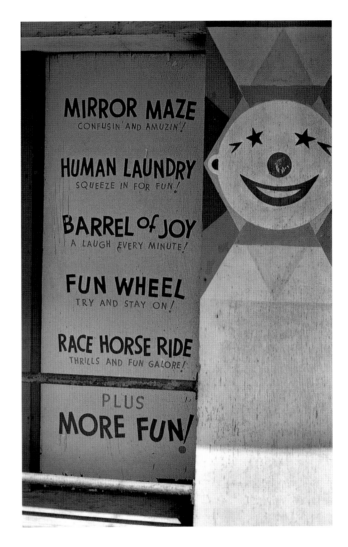

Fun House Attractions, Playland at the Beach
San Francisco, California
Jeff Brouws
c. 1970

the carnivalesque a little closer to answer this very important question.

In most ancient carnival or festival traditions in Europe and Asia, one finds that these events also demanded the mastery of certain skills, and the practice of carnival was a kind of school for laughter. Like other schools, this one served mainly the younger folk. (By the time one was a parent, the lessons of carnival should already have been tucked away into their proper place in the body and in life's rhythm.) Elders worked the event, but youth were its target and hope. The task at hand was to make sure the next generation learned when and how to laugh, a skill as significant as knowing when and how to think, or to pray, or to mourn, or to breathe.

The loss of festival times and traditions in many parts of the world has reduced the ways and means we have to train our children in certain skills of joyfulness. But at the same time, two centuries of industrialization have opened up other times and means for these lessons. The lure of Disney's Magic Kingdom is the hope that parents still hold that their children will know the magic of the carnivalesque. The market for horror films feeds from the desire that laughter overcome fear. The American culture of college partying, and the social reasons to allow this, are modern adaptations to this carnival logic. So, too, the American traveling carnival has turned to children as its main clientele. Children must learn how to laugh, sometimes at their own expense.

ON THE BUS

Laughter at the traveling carnival is not the same as that evoked, say, from a stand-up comedian's jokes. Carnival laughter is a more serious form of humor altogether. It is a laughter that bursts from the lips as the Octopus begins to slow. A laugh at the distortions of a twisted mirror, or at a blast of air in the face in a darkened corridor. And then there is the final laugh, looking back at the midway when the quarters have been lost to impossible games, when the child realizes that playing is something else from winning, something valuable in itself.

We have all met children who cannot laugh like this. We've encountered them in school, returning a simple tease with a threat. We see them in the office, all grown up, but still the same humorless child inside. These are the kids who used to make our parents say, "Someone should teach that child a lesson." But what the kids really needed was a little more carnival laughter. And what they still need to know is that laughter can be more joyfully serious than anything else.

The anthropologist Victor Turner made the observation that life gyrates between two frames of reference. The one in which we seem mostly stuck is a rational frame where the limits and consequences of everything we do constrain our actions and thoughts. The other frame is a space where joyfulness and wonder take over, and where we forget our limitations. In this space we find the means to imagine how we might change ourselves and our relationships with others, our society, and our future. We slip into a world of infinite possibility, for a day, or an hour, or the three-and-a-half minutes of a carnival ride. And when we get back to the

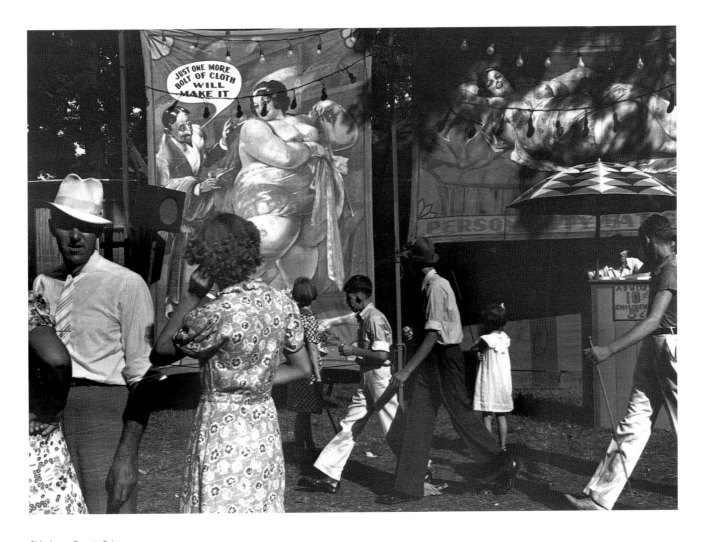

Sideshow, County Fair
Central Ohio
Ben Shahn
1938

ground, the ground is no longer the same, for we have glimpsed it differently. These are our moments of inspiration and innovation, and they are also part of the carnivalesque.

Although we are less organized than we used to be in providing these carnival lessons to our youth, the carnivalesque remains curiously strong in American society. In the 1960s, America experienced times and places in which the carnivalesque returned with a vengeance. For some, San Francisco's "Summer of Love" was a season-long carnival of drugs and sex in Haight-Ashbury. The entire hippie counterculture, at its core, was based on a politics of laughter. Hundreds of thousands of America's youth referred to themselves as "freaks," stealing this label from their parents and neighbors who used the same word with negative intent. Ken Kesey and the Merry Pranksters filled a bus called "Further" with "unsettlers," and headed back east to meet with Dr. Timothy Leary. Abby Hoffman and other "Yippies" executed political farces, and shut down the New York Stock Exchange by throwing wads of dollar bills onto the floor. But there were also reasons to cry. The struggles for civil rights and resistance to the Vietnam War soon drowned out the carnival laughter of the '60s. Yet this laughter, I would submit, remains just under the surface of American life.

Today, the carnivalesque leaks through television shows like *South Park*, films like *Austin Powers*, and the resurgence of stand-up comedy. In the 1990s, America saw more amusement park construction than at any time since the early 1900s. New festivals are being organized in many major cities, festivals that celebrate a carnival spirit of freedom.

Bakhtin likens the carnivalesque to a second life, one that is always with us, at the store, at the office, even at church. This second life doubles our experience in all circumstances, although it shows itself only on occasion. The unchained potential for laughter, a laughter that can overtake any trauma, gives us the strength to move beyond our fears. The power of real laughter is that it reveals the lightness of life even in times of sorrow. We can learn to use this laughter in different ways and times and places, but the younger we find its lesson, the better.

Today, while the traveling midway remains a fixture of civic celebrations nationwide, we have a ready-made venue for carnival laughter. Every summer, millions of American youth taste their first corn-dog, make their first fumbling sexual grope, tackle the ever-challenging Zipper, and go home to bed different than they were scant hours before. And if this difference takes hold, and laughter finds a home, then they have joined the party and realize they're not in Kansas anymore.

References:
Bakhtin, Mikhail. *Rabelais and His World*. Helene Iswolsky, trans. Bloomington: Indiana University Press, 1984. [Originally in Russian as *Tvorchestvo Fransua Rable*. Moscow. Khudozhestvennia literatura. 1965.]
Perry, Paul, and Ken Babbs. *On the Bus: The Complete Guide to the Legendary Trip of Ken Kesey and the Merry Pranksters and the Birth of the Counterculture*. New York: Thunder's Mouth Press, 1990.
Turner, Victor. "Frame, Flow and Reflection: Ritual and Drama as Public Liminality." *Japanese Journal of Religious Studies*, 6/4. 1979: 465–99.
White, Allon. "'The Dismal Sacred Word': Academic Language and the Social Reproduction of Seriousness," in *Carnival, Hysteria, and Writing*. Oxford: Clarendon Press, 1993. Pp. 122–134. [Originally in the *Journal of Literature Teaching Politics*, vol. 2, 1983.]

WELCOME TO THE PLEASURE PALACE

One of the prime examples of "serious" culture shoving other, so-called non-serious practices from the pages of history is the almost complete lack of attention to, and appreciation for, modern amusement spaces as a style of architecture. Modernism in architecture, whether in Frank Lloyd Wright's Prairie Style or in the International Style of the 1930s, self-consciously turned its back on the midway, as it did on the ornamental style of the Gilded Age.

Today we can find entire cities planned and built without even a hint of carnival architecture (Brasília comes to mind). And a drive through the center of most cities reveals an inventory of buildings, none of which could claim a midway heritage. But does this mean that the midway has nothing to offer us architecturally, or is it the result of an earlier banishment of carnival style to seaside amusement centers and temporary sideshows?

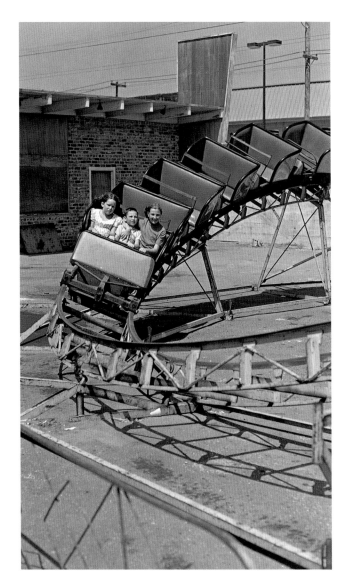

Roller Coaster, Playland at the Beach
San Francisco, California
Jeff Brouws
c. 1970

Recently, the lack of amusement in modern architecture has become the source of its most "serious" critique. The current ensemble of post-modern architectural styles can be connected—and perhaps defined—by an attention to the potential for emotions, and most particularly of amusement, within architecture. And where better to find the potential for amusement in architecture than in an architecture dedicated to amusement? So the time has come to revisit a century of carnival style.

Reexamining the architecture of American amusement, we discover another whole vocabulary for building, a language that Robert Venturi noted decades ago in Las Vegas but that we can push back much further to the beginnings of the twentieth century. And when we look back, we see much that was obscured by our neglect of the midway as an architectural type. To start, we find that millions of Americans pinned their dreams and hopes on these carnival sites. Visions of flight, of technical wonders, and of feats of bravery long shared the midway with the freaks and hootchie-kootchie dancers. Early midways included simulated trips into outer space and spectacles of fires, floods, and earthquakes that provided daily heroics. The midway was a space of wonder.

Nineteenth-century "dime museums," precursors to modern midway freak shows, challenged the cultural preconceptions of the working classes. These museums and their traveling carnival sideshow counterparts compelled their audiences to take a glimpse behind the veil of "nature's mistakes," where the public found ample evidence that the grotesque is also in the eye of the beholder. As bizarre as they were made out to be, the freaks and the naked scowling "natives" on exhibit became, at

the same time, familiar and somehow safe. Several celebrated freaks staged gala public weddings, and their lives were tracked with the same ardor that fans would later show for Hollywood's own freaks: its movie stars. For it takes a parallel heroic to live with either deformity or celebrity in an age of advanced conformity. The architecture of the carnival offers little room for the chicken-hearted. And if half of the dreams included in the cost of admission are nightmares, all of them are worth cherishing.

Sometimes those dreams come true. Many of the technological inventions that define our daily lives—from the telephone to microwave ovens—were first demonstrated at grand fairs and great expositions, where technological wizardry and the wonders of the midway vied for the imagination of the nation, and all for the price of the day's admission. Walt Disney built a carnival park where technology became the central metaphor for most of the offered amusement.

Disneyland is at heart a carnival of technology, particularly of the technologies of motion. The original sketches for the theme park included a midway of games, but apparently Disney realized that the entire park was a great game and needed no other sideshow attraction. Until Disney, the midway had always been kept separate from the exhibits of the fairs. Disney integrated these in his parks, and in exhibits he built for world's fairs. From the submarine *Nautilus*, to the Mainstreet streetcar, to the Matterhorn toboggan ride, motion is the prime metaphor for the Magic Kingdom. The desire to get out and go, by riverboat or train or spaceship, is what Disneyland commodifies and satisfies, if only momentarily.

HISTORICAL ROOTS

This commodification of desire was not new to the modern midway. For centuries, carnival entrepreneurs tracked the regional and local fairs as these circulated around Europe and England. For every head of cattle or bolt of cloth sold, there were also theatrical spectacles to view, acrobats to admire, beer and sausages to polish off, and vistas of bodies either seductive or grotesque (or both) enough to titillate the entire family. In short, there was money to be made coming and going, and the carnival made sure that even the smallest coin would find a new pocket by the end of the day.

Primarily because of a regular need to move on, encouraged by the regional circuits of the agricultural fairs and the rapid market saturation of carnival commodities (how many times in a week will you pay to see the same freak or watch the same acrobat?), the midway was a continually moveable cultural feast. Every fortnight meant a new town and a fresh crowd, and each season brought new acts, or, at least, new names for old acts. The architectural features of these carnivals were constrained by their necessary portability to garishly painted cloth, rope, and thin wooden members—only what would fit on the wagon. Then something remarkable happened to carnival architecture: the machine arrived.

The first machines, in the early nineteenth century, provided automated motion to rides that were previously driven by hand. It took still another invention to change the amusement landscape: the railroad. The advent of the railroad (and, later, the tram and the subway) inverted the spatial logic of the carnival and the fair.

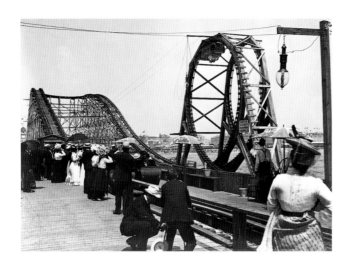

Looping the Loop
Atlantic City, New Jersey
Photographer Unknown
c. 1901

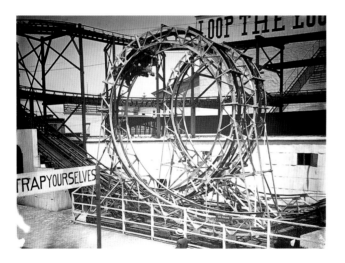

Looping the Loop, Luna Park
Coney Island, New York
Photographer Unknown
c. 1903

Beginning with the Crystal Palace in England in 1851, stationary (if temporary) fairs would grow in size and scale, and the crowds would travel to them by train. From this reversal of the traveling equation, the amusement park was born as a tourist destination. And in these parks were new machines designed to twirl and fling the body of the patron in a controlled semblance of freewheeling motion: the thrill ride.

The parks themselves grew into hyper-sized pleasure arenas, each one competing with its rivals in the speed and size of its machines and the grandiose schemes of its architecture. Railroads and technical improvements to mechanical rides also allowed for what happened next. Small-scale amusement parks were able to be loaded onto trains and travel to many smaller cities and towns in a single season, marking the beginnings of the modern traveling carnival.

If today the chances of getting hurt are no greater on the carnival lot than in your backyard, the fear of injury is still stimulated by the way the rides and games are presented. The carnival remains a fine piece of work, running on all cylinders, everything in motion. From the neon lights to the bunting and banners, it looks fast just sitting there. Painted in day-glo colors and edged in neon, traveling carnival rides use the smallness of their motions to accelerate the sense of speed. The Zipper is a good example: barely twenty feet tall, it moves on three axes at the same time to simulate the speed of a raging roller coaster.

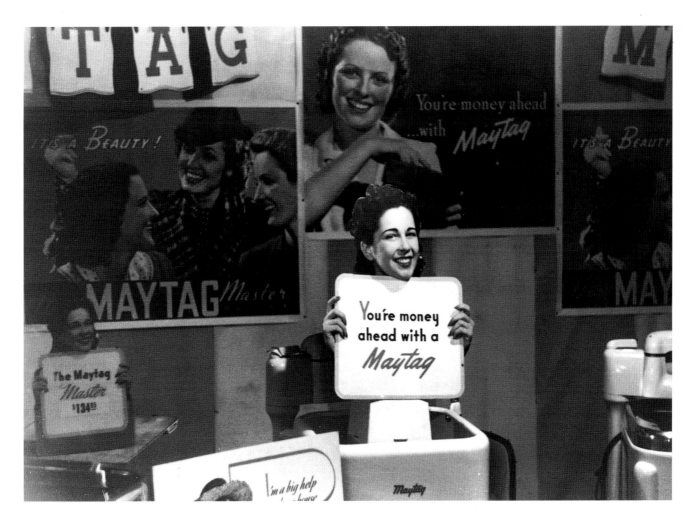

Maytag Exhibit at Champlain Valley Expo
Essex Junction, Vermont
Jack Delano
1941

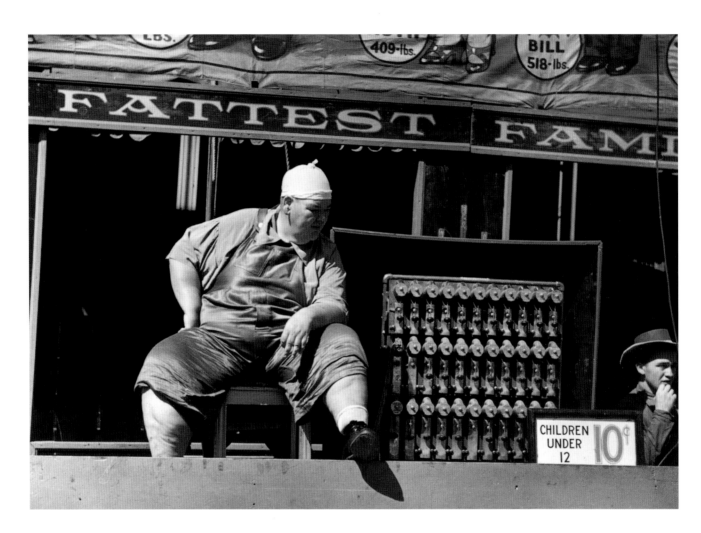

Sideshow
Rutland, Vermont
Jack Delano
1941

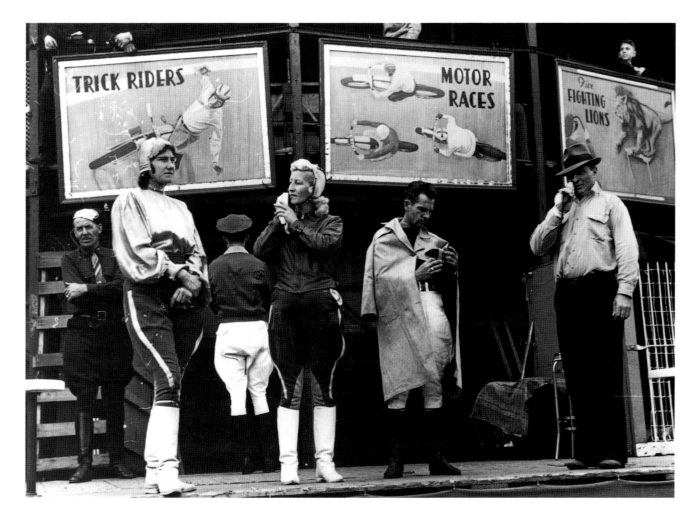

Daredevil Drivers at Champlain Valley Expo
Essex Junction, Vermont
Jack Delano
1941

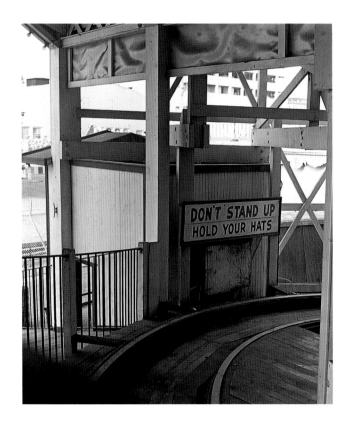

Cyclone Racer, Don't Stand Up
Long Beach, California
Tom Moore
1968

The carnival is where the modern architectural fetish for the machine first acquired its most direct connection. While Italian futurists only dreamed of cyborg cities where humans and machines interpenetrated each other, traveling carnivals were already packing human bodies into twirling contrivances for minutes of frenzied stimulation. Here, too, the sophistication of modern design was put to its test, for as carnival contraptions became larger and faster there was no room for mechanical error.

The carnival at the county fair reconnected the mechanized, modern midway with its ancient roots, moving from town to village in rhythm with the consumption of agricultural commodities. The display of prized sheep and pigs, the judging of pies and pickles, and the sale of tractors and steak knives all take place within earshot of the screams of the carnival. If modernity is "the machine age" the Fordist factory is its beating heart, but the midway is its core erogenous zone.

The history of the architecture of American amusement has yet to be fully appreciated, and there are many misconceptions about its place in the twentieth century. For most of this century, carnival style was pushed to the margins of the city and also within the practice of "modern architecture," even though there is no architecture arguably more modern than that of the mechanized midway. While modernist houses and office buildings were designed metaphorically as machines, carnival architects designed actual pleasure machines and dressed these in a cosmopolitan architecture of amusement. The modernists stripped their buildings of Victorian ornament, while amusement park designers piled

ornament upon ornament, and then covered the whole shebang in millions of lights. Here was architecture as a machine for marveling.

After thirty years of posturing and debate, we can now see that post-modernism in architecture is also an affirmation of an earlier architectural modernism: a modernism that first created the great expositions and their carnivals, and then peppered the edges of the American city with pleasure grounds that were as implausible and seductive as the International Style skyscrapers in the middle of town were rational and cold. Here we are looking at the source of the playful gymnastics of post-modern style and its relation to space and to the body.

Robert Venturi looked to Las Vegas, but Las Vegas took its lessons from an older and deeper vein of architectural imagination. From the European situationist architectures of the '50s and '60s, and the work of Frank Gehry and Richard Meier, to more recent projects of the Jerde Group (notably, Universal City Walk), we can find a carnivalized architecture achieving its own place within the urban fabric. Like Disney, post-modern architects are now reintegrating the chaos of the midway with the sterile formality of the Great White City. After a century on the outskirts of towns, carnival architecture can now be seen blossoming in city squares and shopping plazas. And while the carnival midway is today on an economic decline, its architectural influence may be greater than ever before.

Cyclone Racer, Detail
Long Beach, California
Tom Moore
1968

Reference:
Venturi, Robert, Denise Scott Brown, and Steven Izenour. *Learning from Las Vegas: The Forgotten Symbolism of Architectural Form*. Cambridge: MIT Press, 1972.

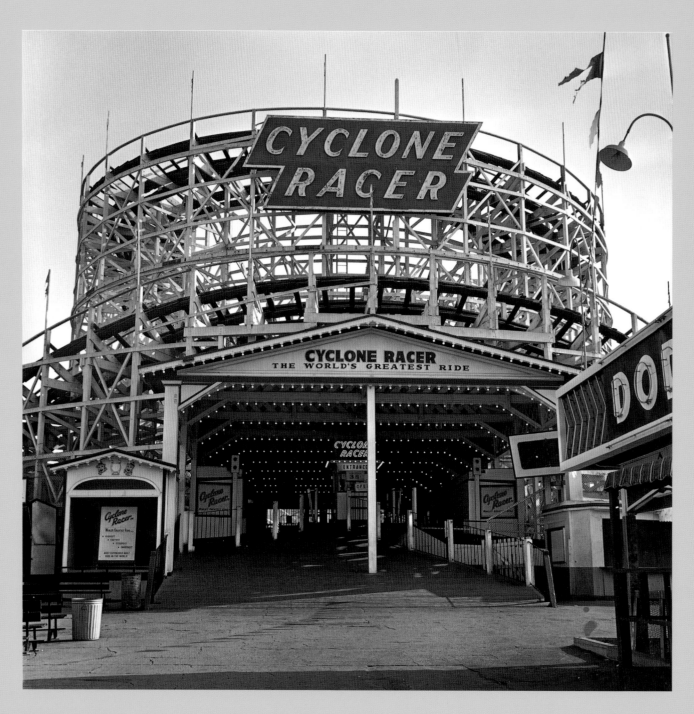

Cyclone Racer
Long Beach, California
Tom Moore
1968

IRON JOHN MEETS ZIP THE PINHEAD

Life, we are often told, used to be a lot tougher than today. The specifics of this claim change across the decades, but the message is clear: we don't face the same kinds of challenges others used to, and somehow we are less able because of this. From fending off saber-toothed tigers with spears, to building homesteads out of virgin forests, to making a living in mines and factories before the advent of unions, we are always reminded that the everyday dangers and troubles of our elders and their elders were somehow more significant than those we face today.

When our elders tire of reminding us of this, they sometimes also remember that discipline, patriotism, manners, indeed civility itself have somehow disappeared from everyday life. And, while there is mostly hindsight romance in these pronouncements, there is also a sincere seed of worry: where do we learn today how to face the dangers

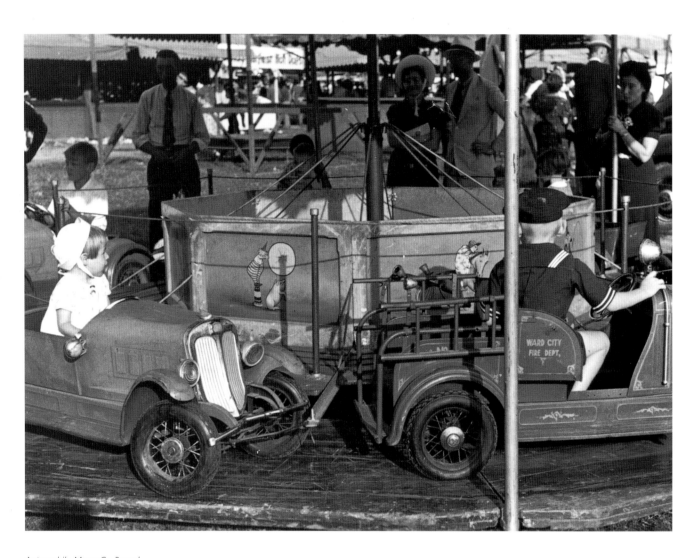

Automobile Merry Go Round
Donaldsonville, Louisiana
Russell Lee
1938

that still might rise to challenge us as individuals and as a society?

Few would argue that these old risks to life and limb or the paternalism of the premodern family need to be revived just to keep us on our toes, or from stepping on those of our betters. Our lives are significantly different from those of our ancestors. Today, we do not want to be told what to do, but rather we seek a historically unprecedented level of independence as our natural right.

And yet, despite our claim on independence, mutual dependence is the underlying condition of our social life. When pushed, we must admit to our own softness, to our lack of survival know-how, and to our near total dependence on others (and also on machines) for almost everything we do. Sociologists have posited that this juxtaposition of radical independence with an equally fundamental mutual dependence must create a deep well of fear in each of us. This fear they call "angst" (the German word for "fear"), and if we don't feel this, they argue, we probably should.

This angst is the terror of knowing that our lives depend on a host of strangers, and that the lives of these strangers are similarly dependent, and that society, this Ship of Fools, has nobody actually at the helm. Fortunately, its antidote is quite simple: you find a challenge and meet it, then go on to find another. After a while you realize that you can be strong and still depend on others. For decades, the carnival midway presented us just such challenges, and in meeting these we learn how to trust in ourselves. The carnival is not the only, nor the final, venue for learning trust, but it may be one of the first we encounter, and it might just lead us to try others. The carnival is just a small step off the per-

pendicular. From there you are on your own. And that is precisely the point.

Before about 1960, most people didn't just go to the midway, they collided with it, and in that moment they found out more about themselves than years of school could tell them. There were tests at the carnival that didn't come with a study guide, trials that reached an unavoidable verdict. Failures and triumphs in equal measure. And not all the tests were physical.

The carnival in its first fifty years was also the province of the bizarre. One essential quarter of this realm was the freak show. The freak show's spectacle of human diversity—from physical deformity to ethnographic titillation—fed a voyeuristic hunger in the assembled crowd of "townies" (otherwise known as "marks") raised on a daily diet of God-fearing normality. The naked misery on display, at once repelling and intriguing, generally reinforced the sense of superiority that even the generally poor, mainly rural, and mostly white townies might summon as their birthright. While some of the bodies on display achieved an odd measure of celebrity—Tom Thumb performed for the Queen of England—most of the "freaks" in the shows simply had nowhere else to go.

By the end of the 1960s, when hundreds of thousands of young Americans called themselves freaks and when television brought home a world of otherness, and when social programs allowed folks who might formerly have been employable only as freaks to find work and dignity in other occupations, the midway gave up its freak shows. At about the same time, many of the actual physical challenges—the games of strength and agility—were eliminated because of insurance issues (broken

wrists heal slower than busted piggy banks). With the decline in variety acts at carnivals due to the lure of television, the abandonment of freak and sex shows and games of strength stripped the midway of its adult entertainment. And so today, adults at the midway no longer collide with visions and machines that can push them beyond their limits. Today the carnival is strictly for kids, no matter how old they are.

The carnival is today a vestige of those rites-of-passage that gave sure measure to a growing child's adult aspirations. While the midway was always as gendered as the rest of society, today its challenges are open to all. Young girls and young boys, little Kaitlins and Dustins all have the opportunity to satisfy the need to find and hold onto a sense of physical accomplishment.

When they are older, these Kaitlins and Dustins find new challenges at the midway. Here is where the first kiss is stolen, the first thigh revealed, and where budding muscles show. Bodies thrown together in a cage of spinning metal explore one another without intention or shame. And back on the ground, someone always wins the game, to the attention and admiration of the other hopefuls. This brief moment of fame, a jolt of victory, is for some the only chance at this elixir.

OUR CARNIVAL FUTURE

Today, even more than in the early part of the twentieth century, our lives surround us with safety nets that let us forget where the dangerous boundaries lie. We live in bubbles of civil liability and social responsibility. And so, the same sociologists who worry about angst also raise warning flags about the extent to which everyday life is today sequestered from much of society's actual workings—most particularly from life's biological facts (illness, madness, death, and birth), but also from the unpleasant facts of mass production (slaughterhouses, strip mines, clear-cut forests, sweatshops, etc.).

Hiding from these facts does no more to solve the problems they represent than avoiding seeing a doctor will make that mysterious lump go away. There are finalities around us we need to see. Curiously, at the same time we hide from the circumstances most intimate to our personal lives, an impersonal world of violent spectacles is brought into our homes. Daily we are presented with televised visions of violence, inhumanity, and war, all happening somewhere else to people we have never met, visions that should be more terrifying than any rubber monster at a midway house-of-horrors. And then television melodramatics—from daytime soaps to sensationalistic talk shows—simply remind us that other people have lives more interesting than ours.

No wonder it seems that we've lost the means to find the far edge of our own emotions and abilities and so shrink back further into the comfort of feeling and trying less than we might. Apart from the sudden terror of crime and car crashes, we encounter so few direct challenges to our bodies and emotions that two new fears are born: a fear of risk more profound than risk itself, and a dread of spontaneous emotional expressions.

Chapter 3, "The Politics of Laughter," discusses carnival laughter and humanity's long affair with the carnivalesque. Here we need to admit that even this laughter cannot overcome our fears the first time. Like most things worthwhile, the laughter that conquers fears also takes practice, and relies on a

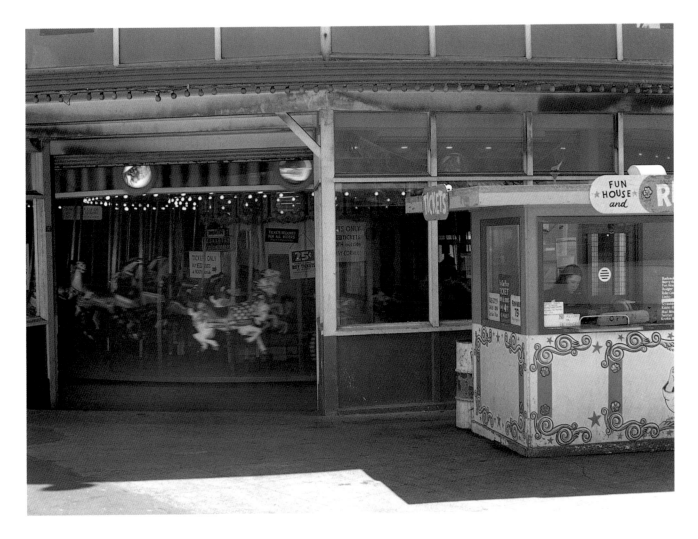

Carousel, Playland at the Beach
San Francisco, California
Jeff Brouws
c. 1970

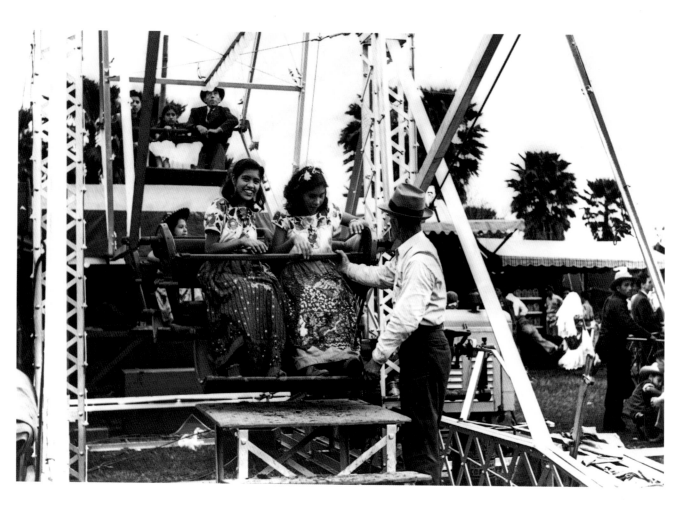

Ferris Wheel
Brownsville, Texas
Arthur Rothstein
1942

personal history of acquiring certain skills.

The upside is that we can get better at this, with the carnival midway as our laughter boot camp. It may not always be pleasant at the time, but when we tackle carnival risks, we signal a desire to strengthen our own emotions, and we gain an awareness of both our vulnerability and our invincibility. Taking a chance at the carnival is a small first step toward knowing where and when to take other chances, how to laugh when the game is lost, and that there is always another chance to win.

The midway brings the child's life into a new focus and reminds children when to be fearless. We need to help our children seek out the risks that make them stronger. And we need a carnival where adults can also learn to laugh. Today, perhaps more than before, we need the carnival to show us our limits and help us push these to new levels.

So, next summer, when the carnival comes to town, make a beeline for the midway. Plan your own carnival collision. For a few bucks and the grit to climb on board, you can step away from the perpendicular and find new footing in the preposterous. And in fifty years you can tell your grandchildren how dangerous life used to be before virtual-reality computer simulations replaced today's mechanical contrivances.

Fun House, Playland at the Beach
San Francisco, California
Jeff Brouws
c. 1970

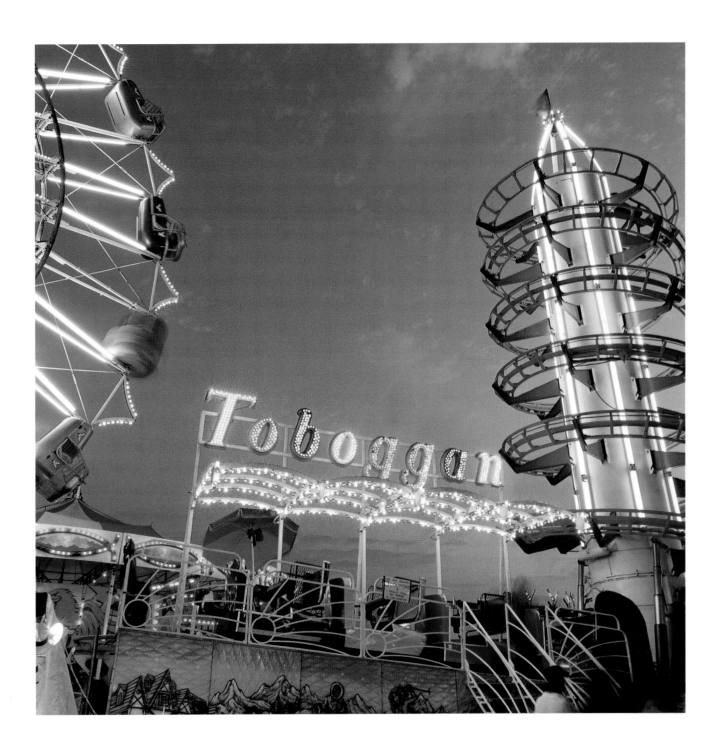

TOBOGGAN (SUNSET) / Ventura, California 1989

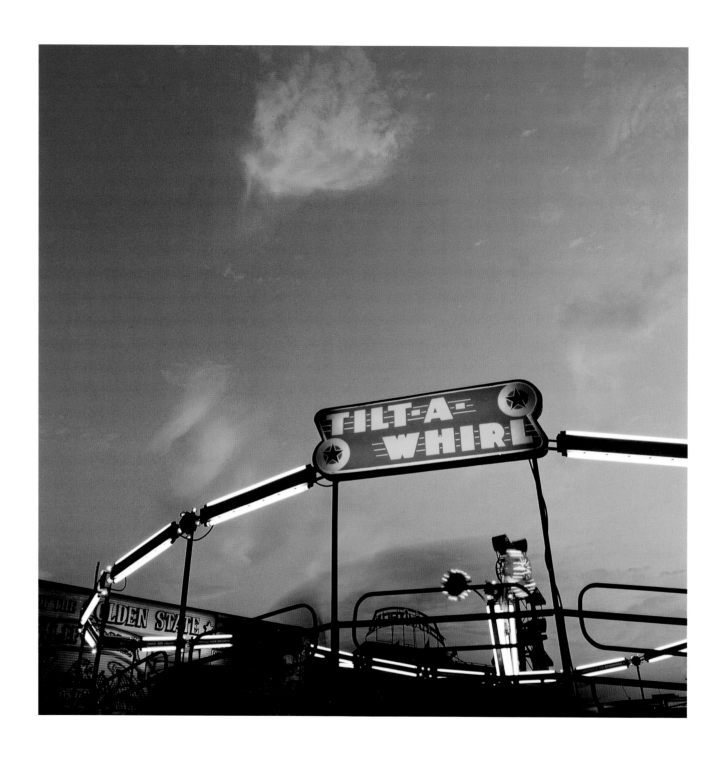

TILT-A-WHIRL / Ventura, California 1988

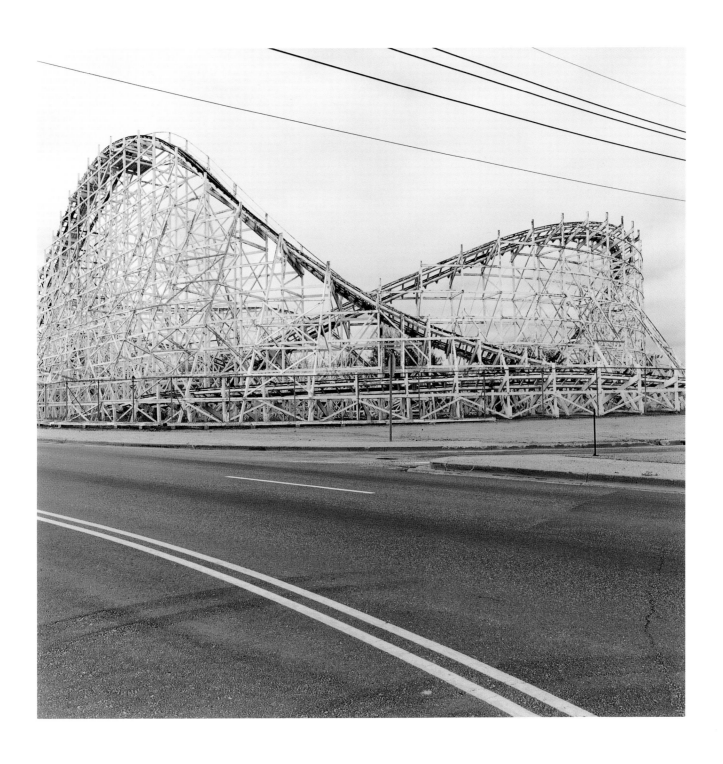

CYCLONE #2 / Denver, Colorado 1990

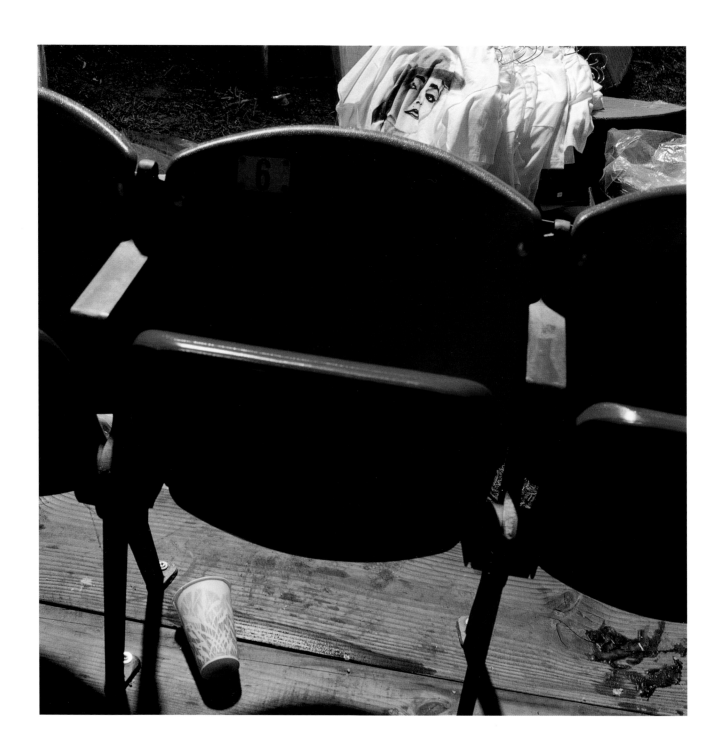

MADONNA / Santa Maria, California 1989

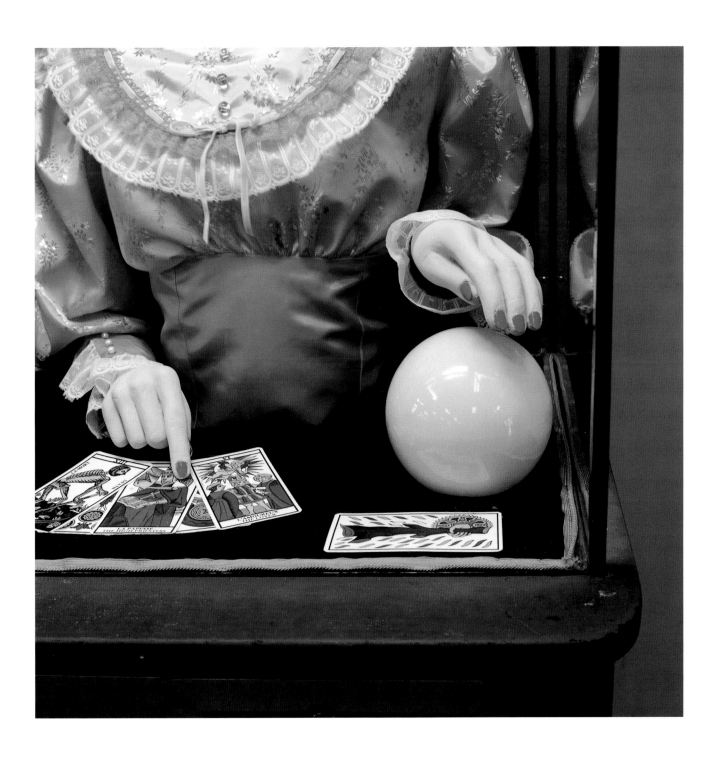

FORTUNE TELLER / Santa Cruz, California 1991

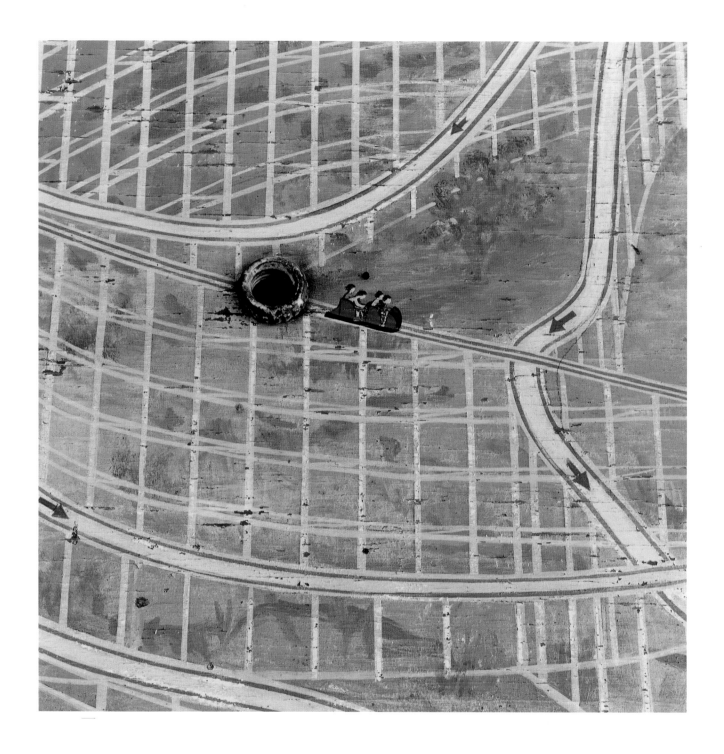

COASTER PAINTING (DETAIL) / Denver, Colorado 1990

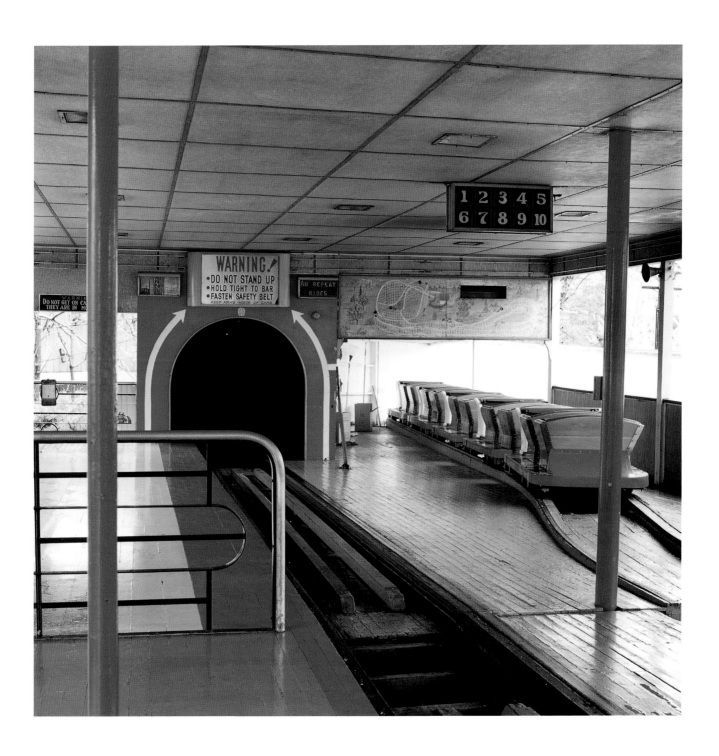

LAKESIDE COASTER (RED) / Denver, Colorado 1990

WHEEL / Ventura, California 1988

DODGEM / Connecticut 1991

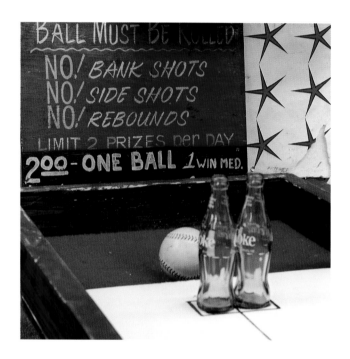

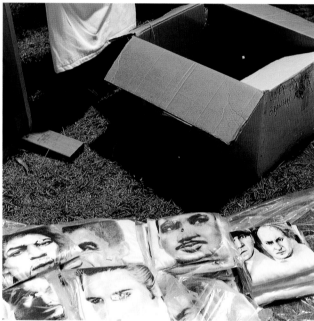

104 $2.00—ONE BALL / Ventura, California 1988 T-SHIRTS / Santa Maria, California 1989

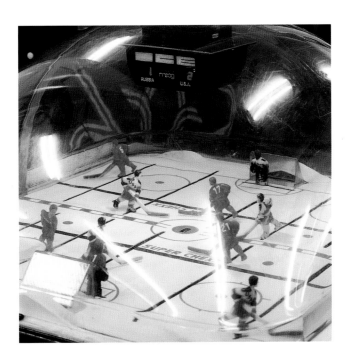

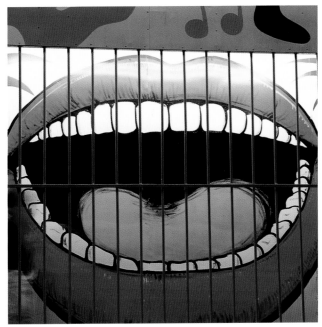

HOCKEY GAME / Santa Cruz, California 1991 MOUTH / Lompoc, California 1989

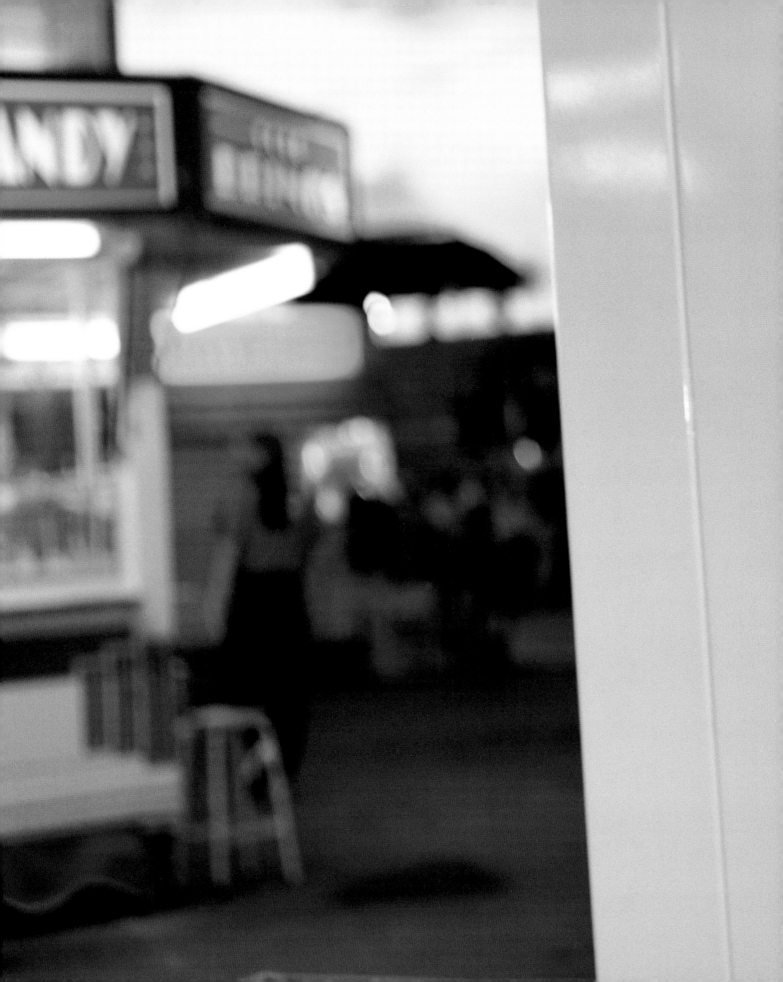

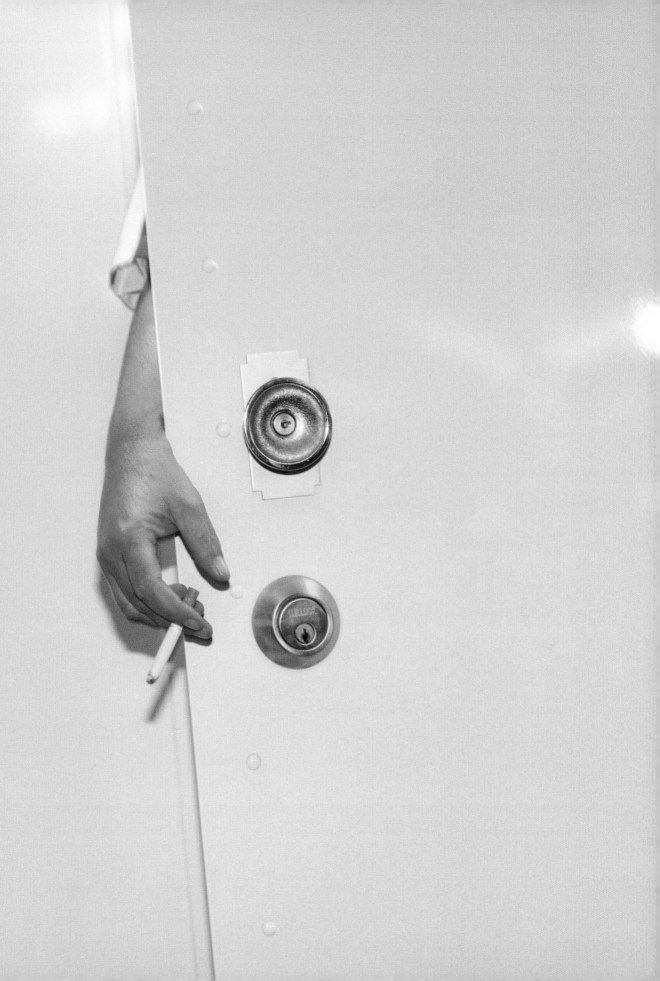

OPERATION THUNDERBOLT / Santa Cruz, California 1992

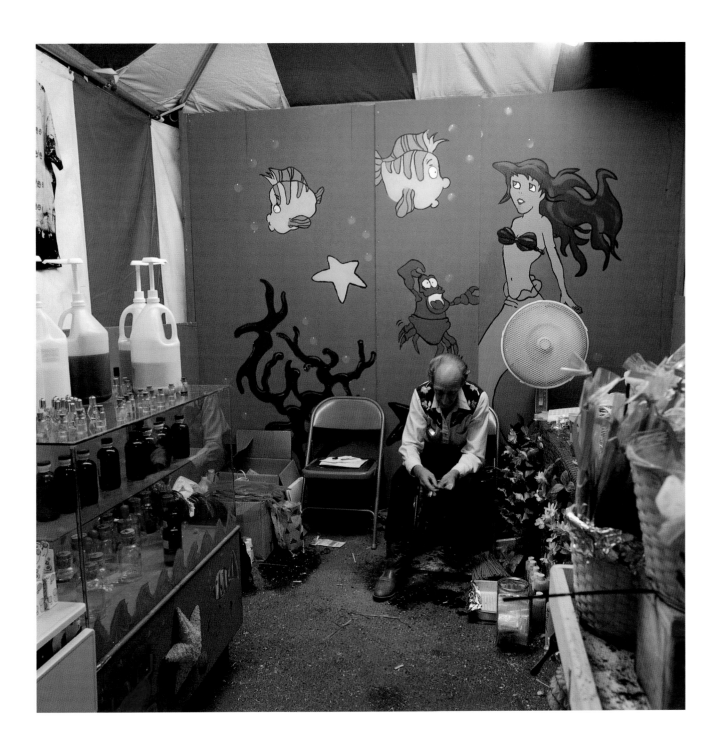

CARNY AND MERMAID / Ventura, California 1988

GUN / Ventura, California 1989

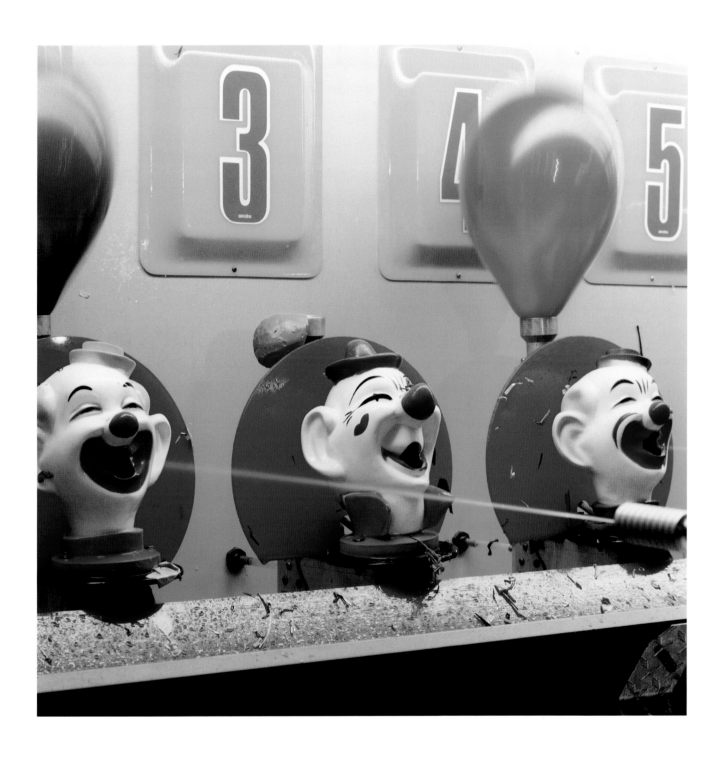

3, 4, 5 / Ventura, California 1989

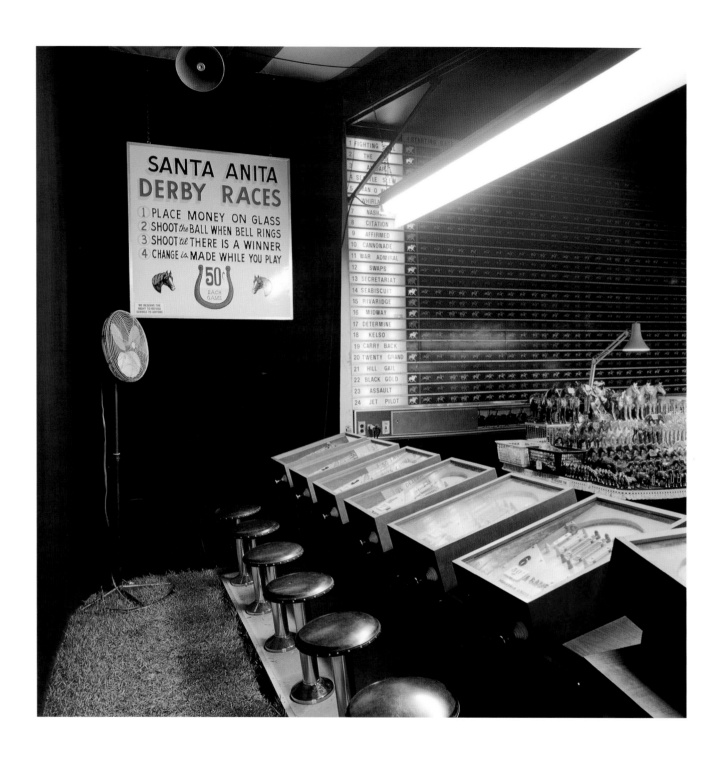

DERBY RACES / Santa Rosa, California 1989

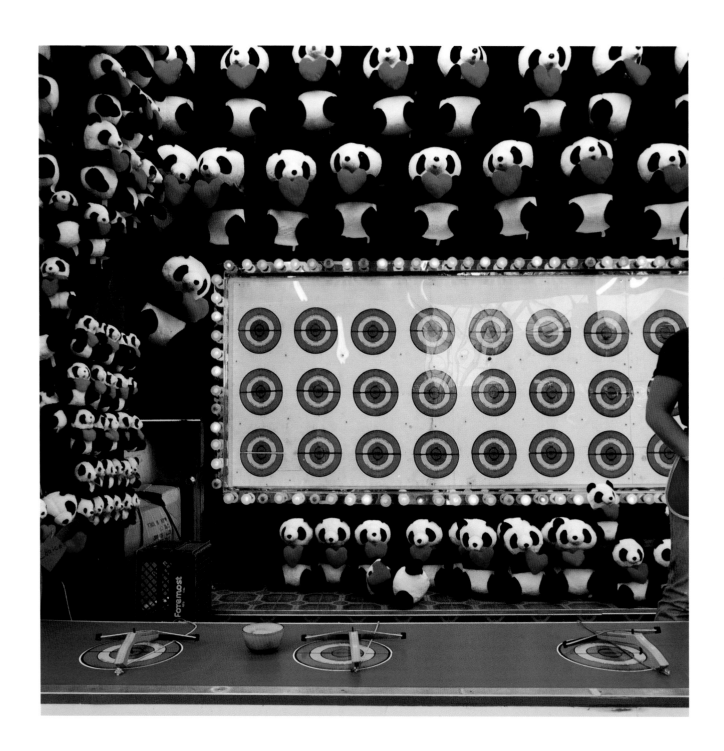

114 PANDA BEARS / Ventura, California 1987

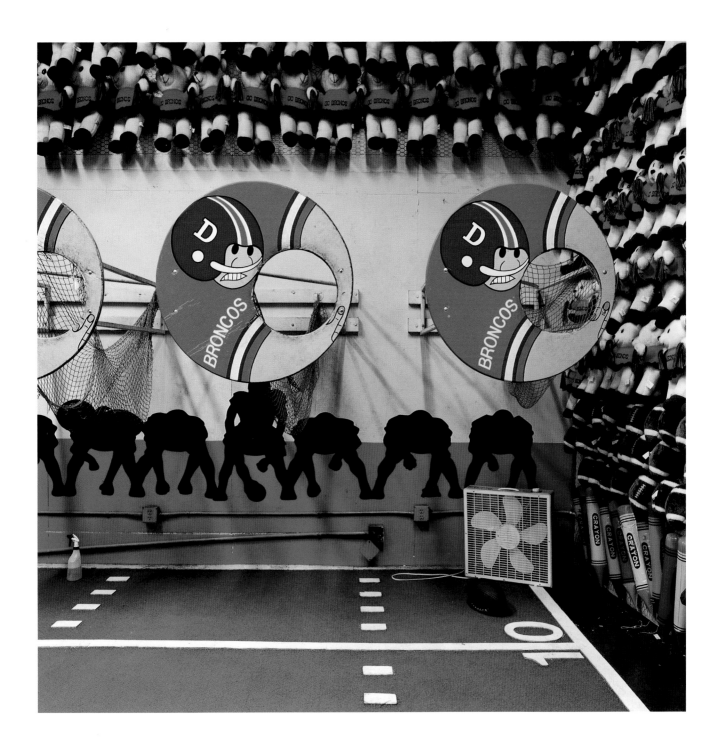

BRONCOS / Denver, Colorado 1990

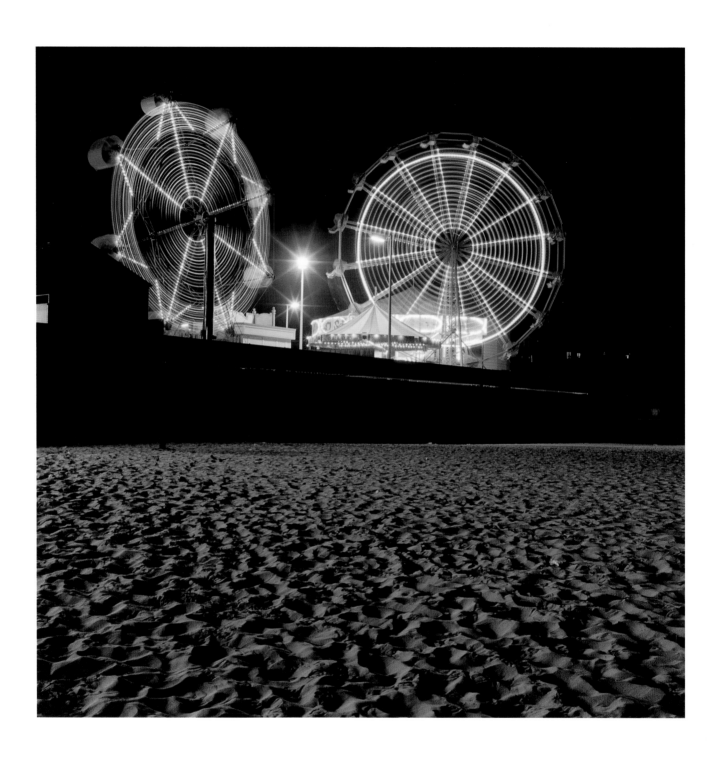

BOARDWALK AND SAND / Santa Cruz, California 1994

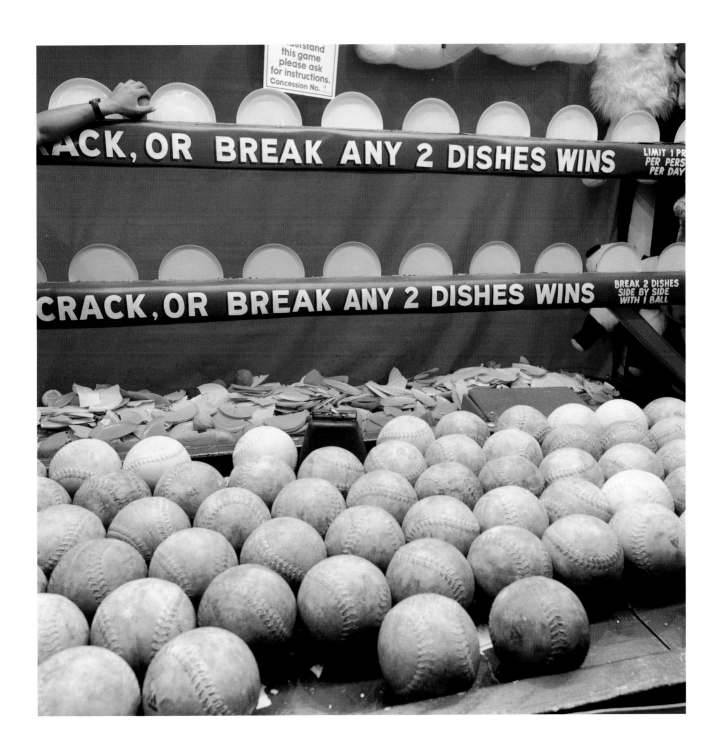

BREAK THE DISHES / Ventura, California 1989

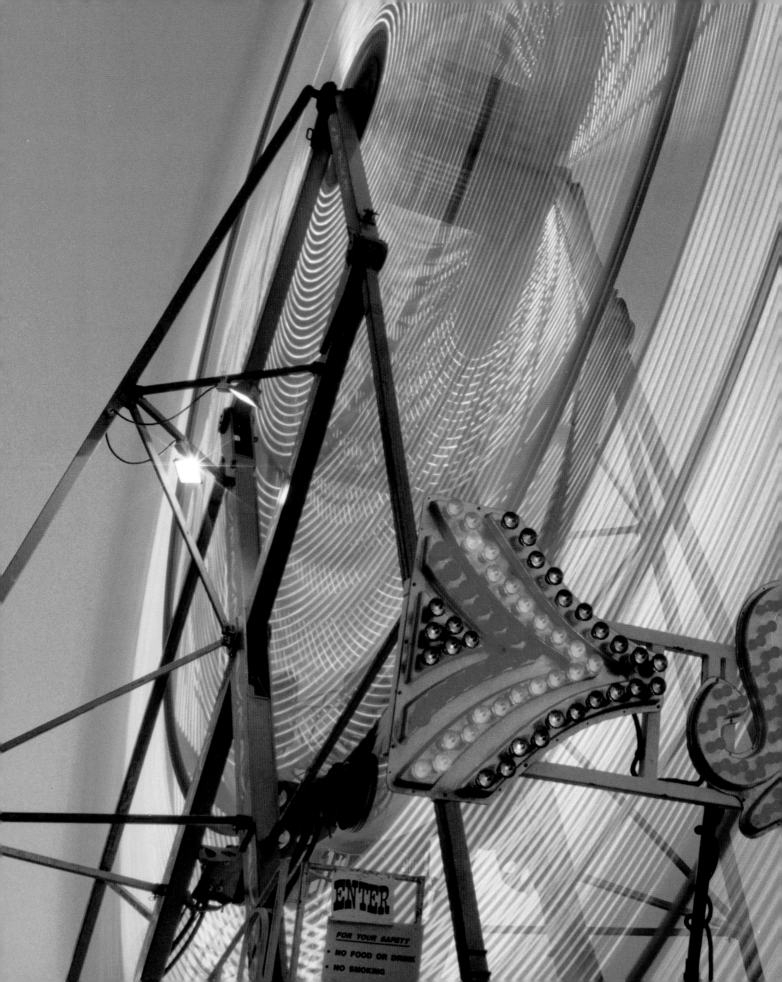

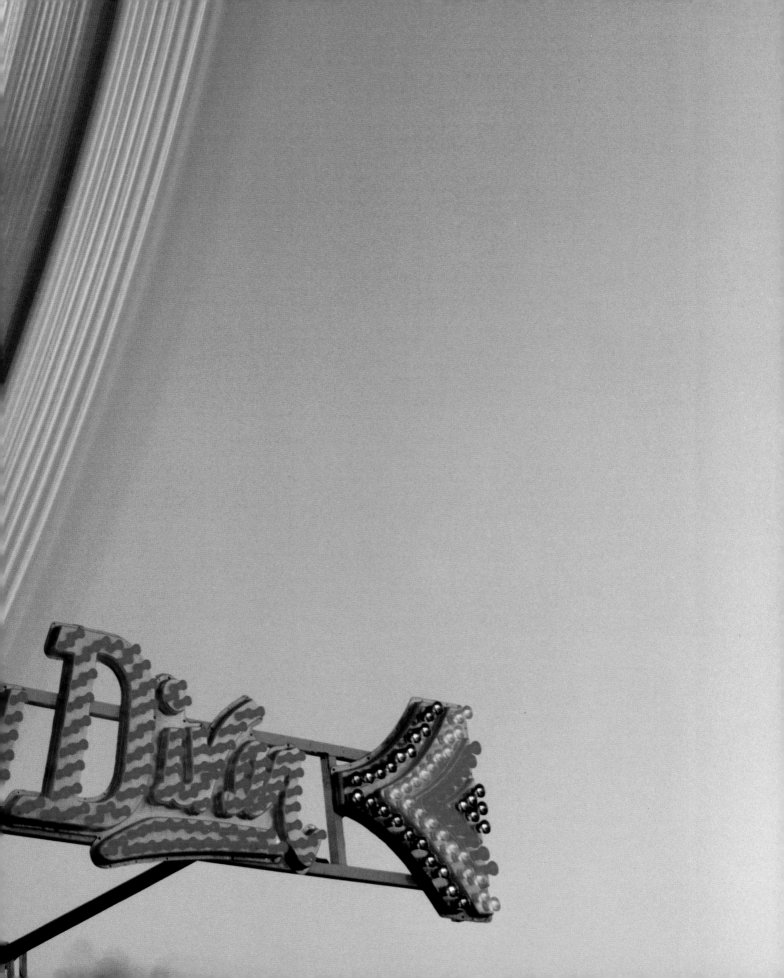

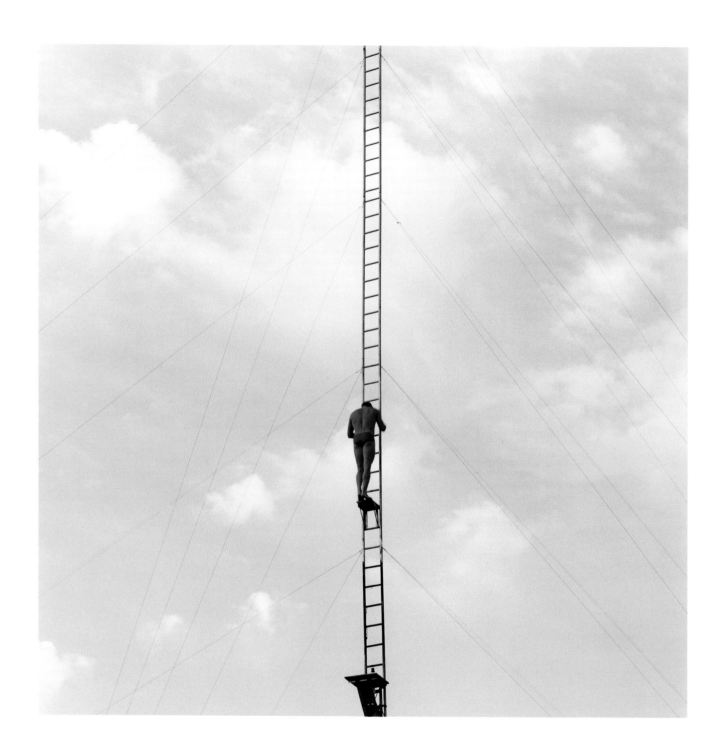

HIGH DIVE / Ventura, California 1988

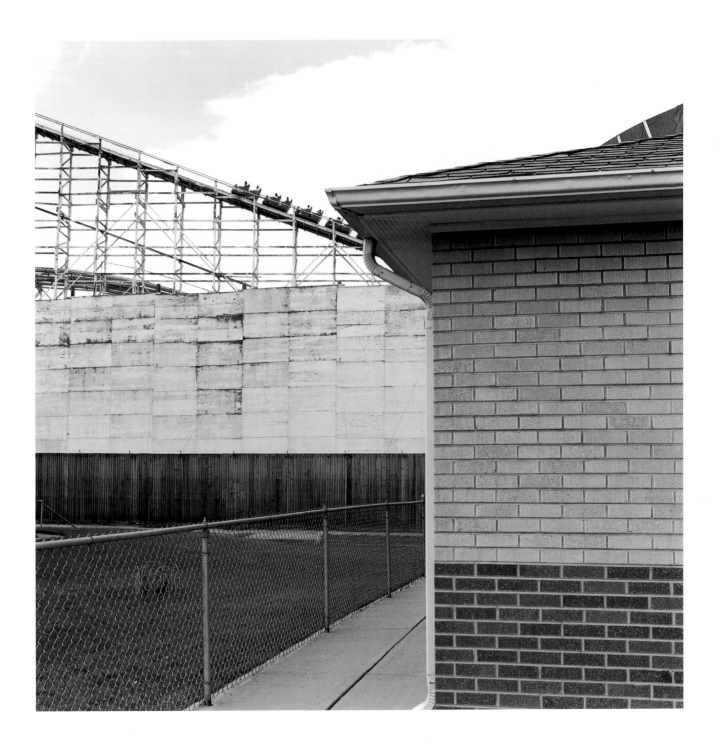

COASTER AND HOUSE / Denver, Colorado 1990

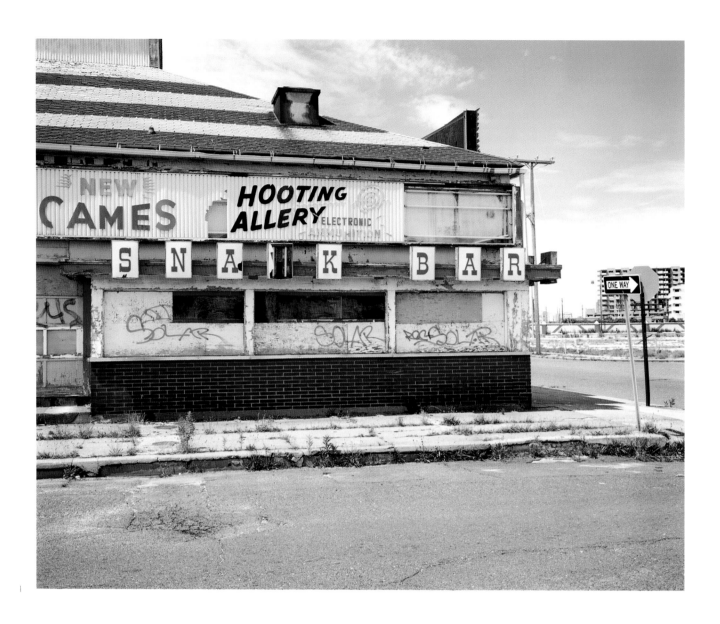

SHOOTING GALLERY / Asbury Park, New Jersey 1998

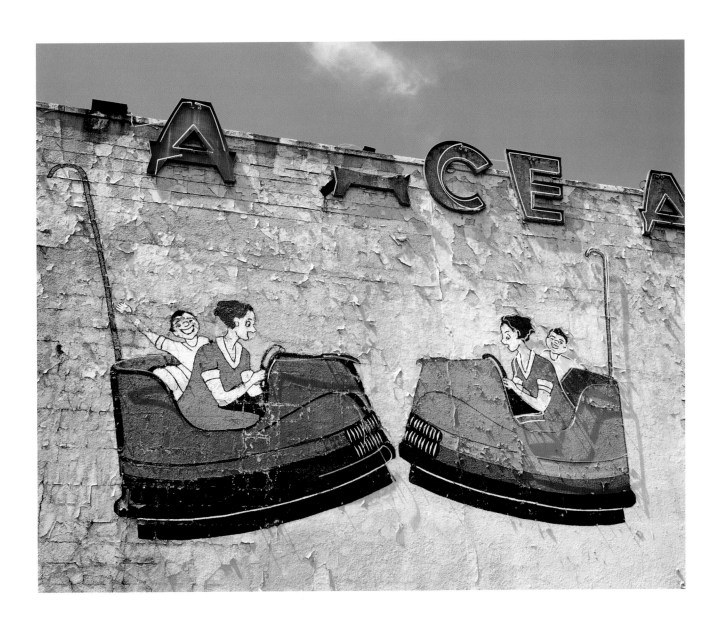

TWO BUMPER CARS (HEAD-ON) / Asbury Park, New Jersey 1998

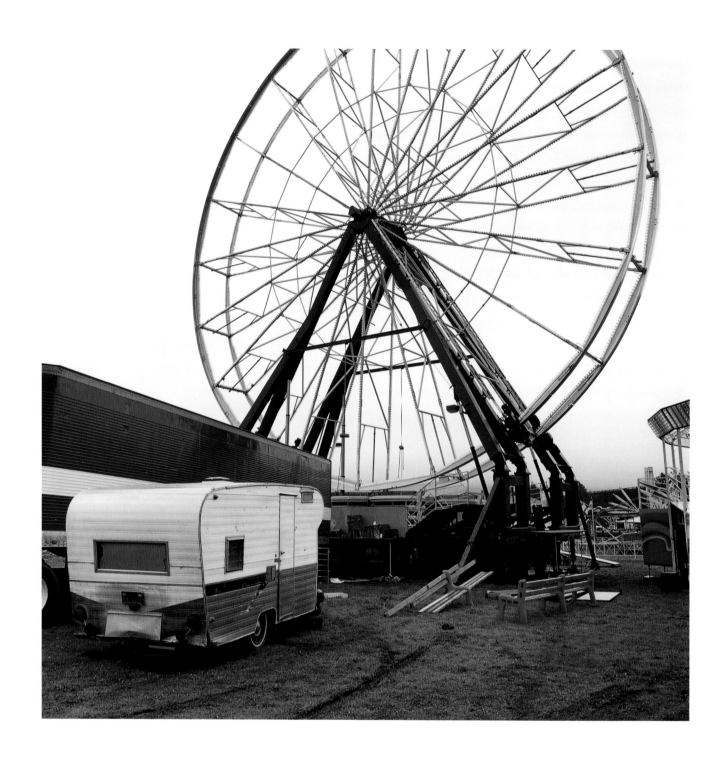

TRAILER, FERRIS WHEEL / Daly City, California 1991

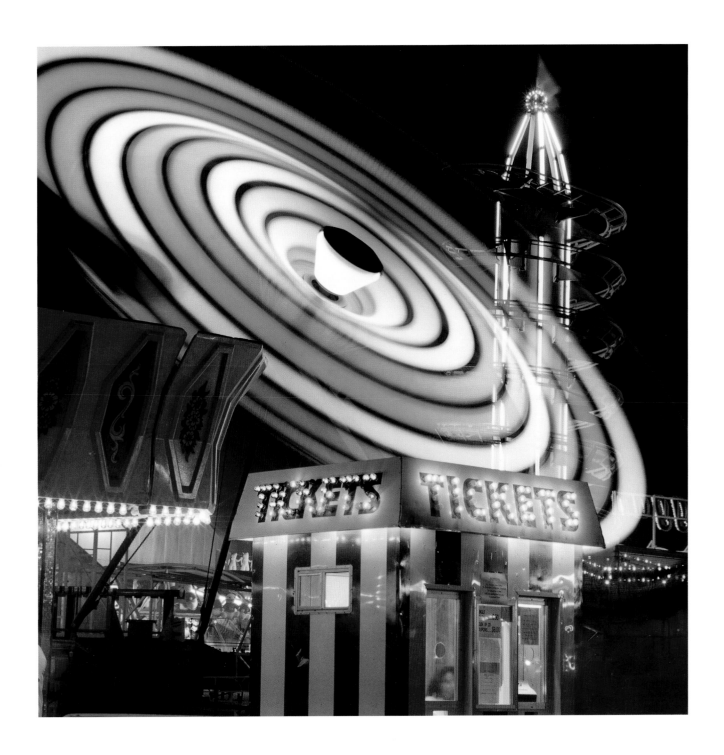

TICKETS / Ventura, California 1987

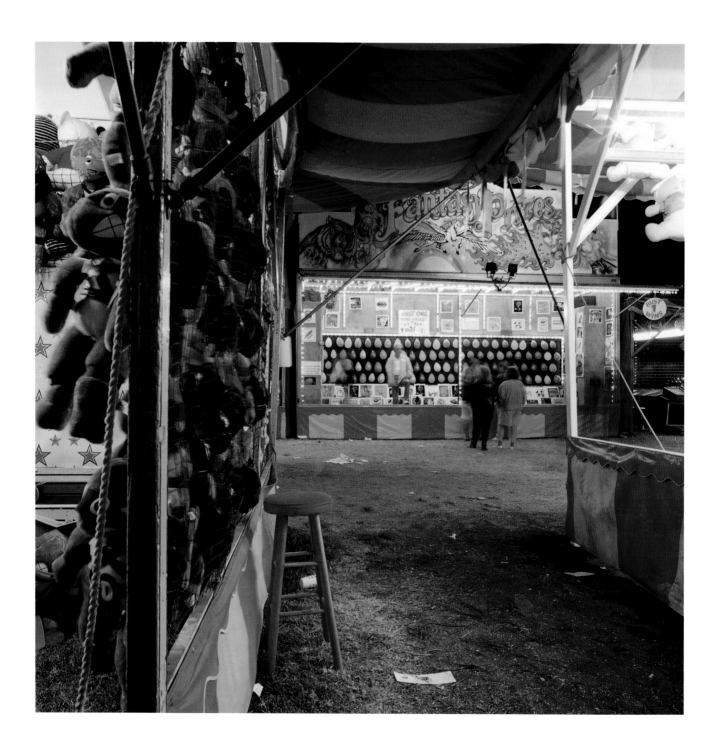

RED STOOL / Santa Rosa, California 1989

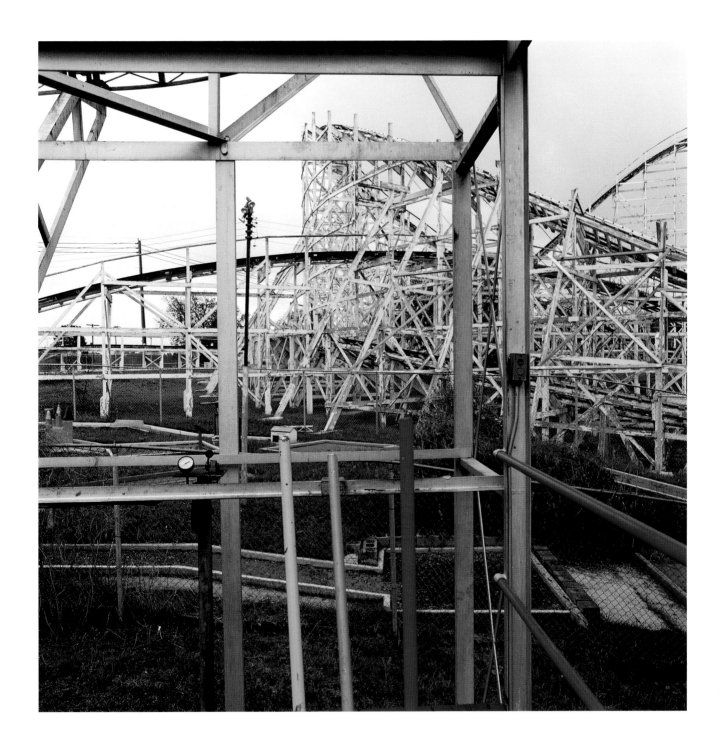

CONTROL HANDLES (RED, YELLOW, BLUE) / Denver, Colorado 1988

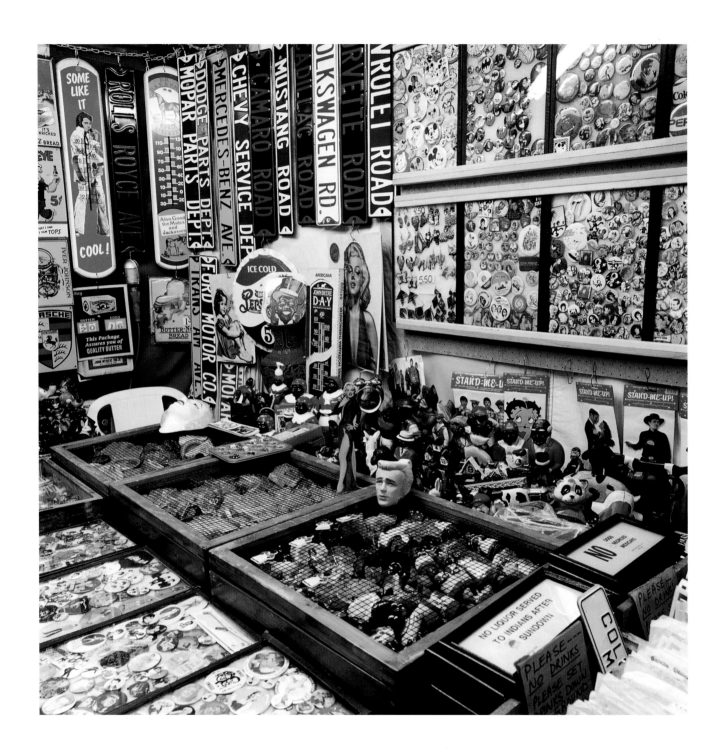

SOUVENIRS (JAMES DEAN) / Ventura, California 1988

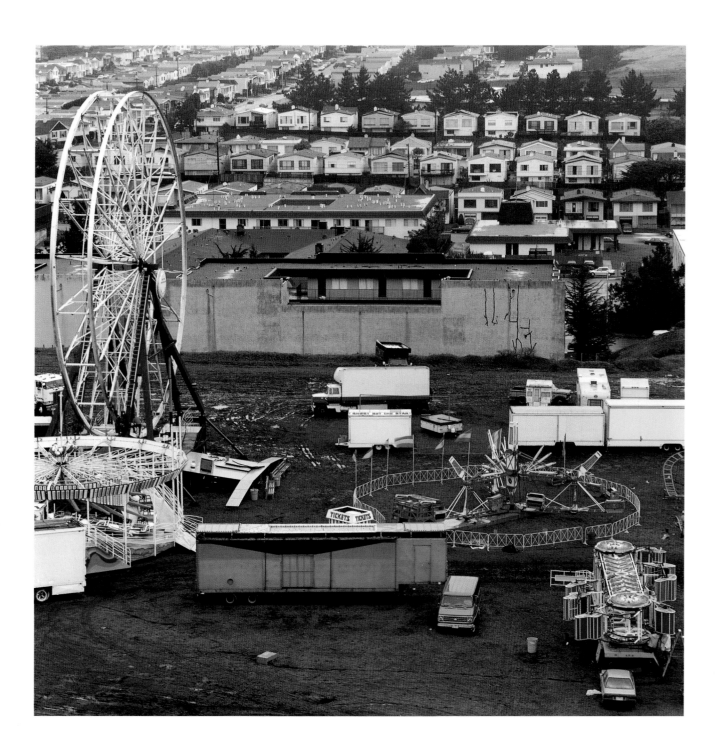

FERRIS WHEEL AND HOUSES / Daly City, California 1991

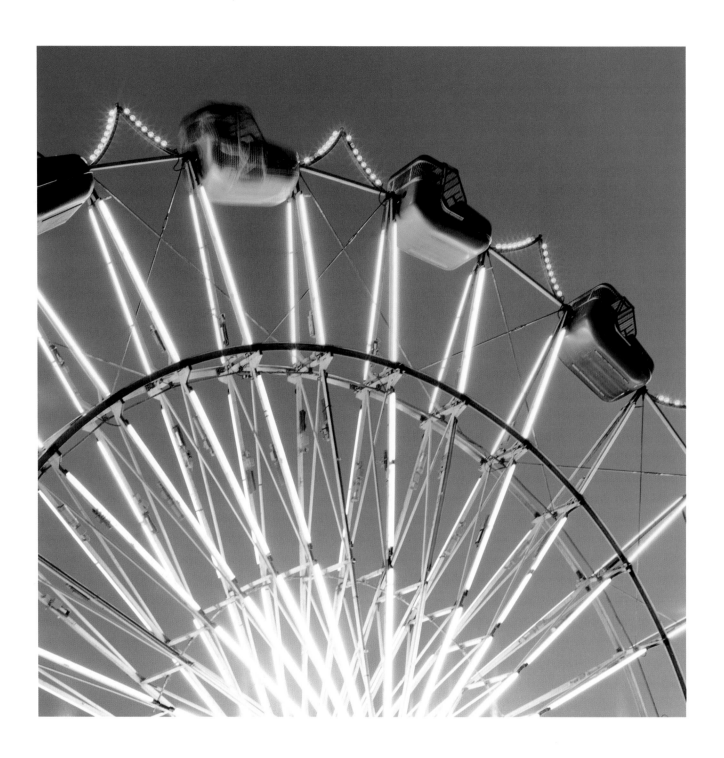

FERRIS WHEEL (DETAIL) / Santa Barbara, California 1989

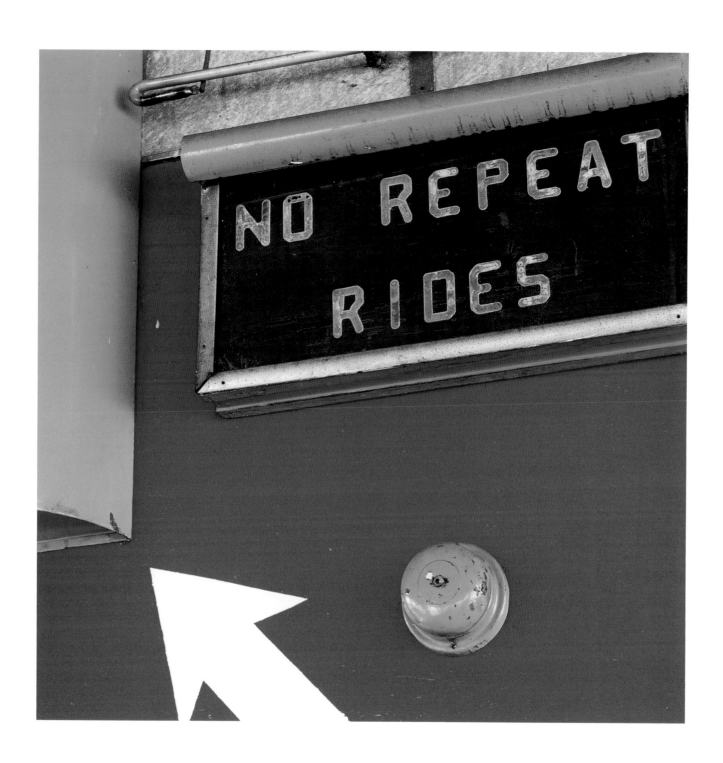

NO REPEAT RIDES / Denver, Colorado 1990

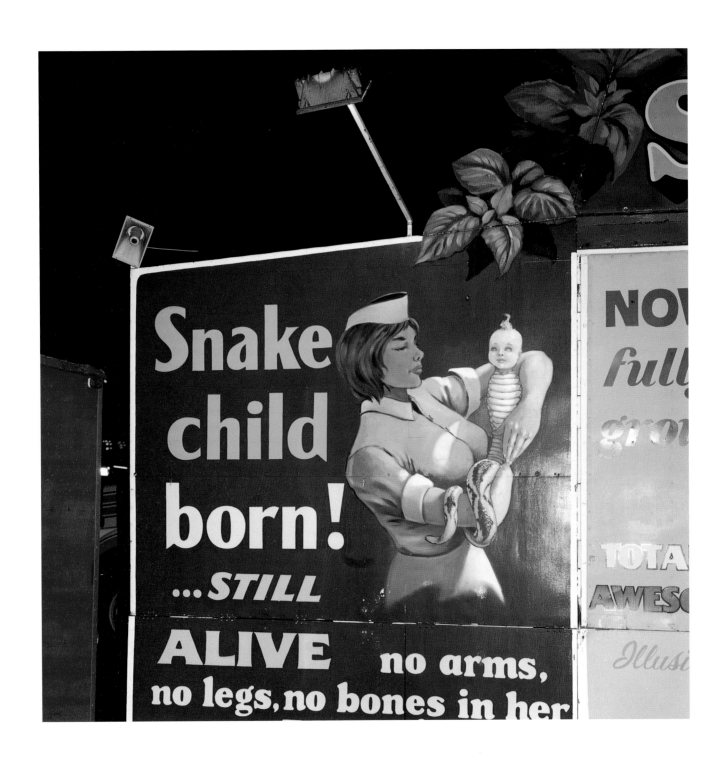

SNAKE CHILD / Rhinebeck, New York 1998

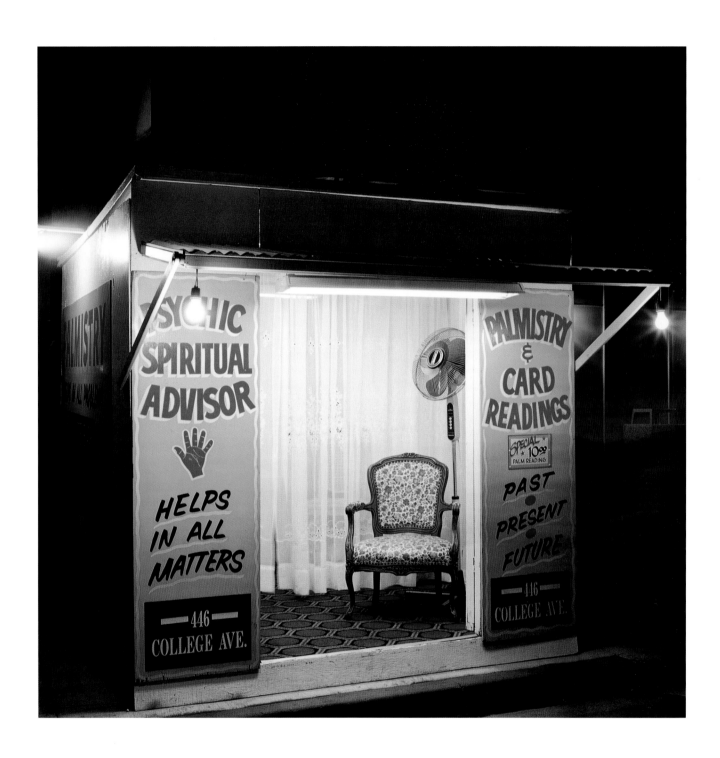

PALM READER / Santa Rosa, California 1989

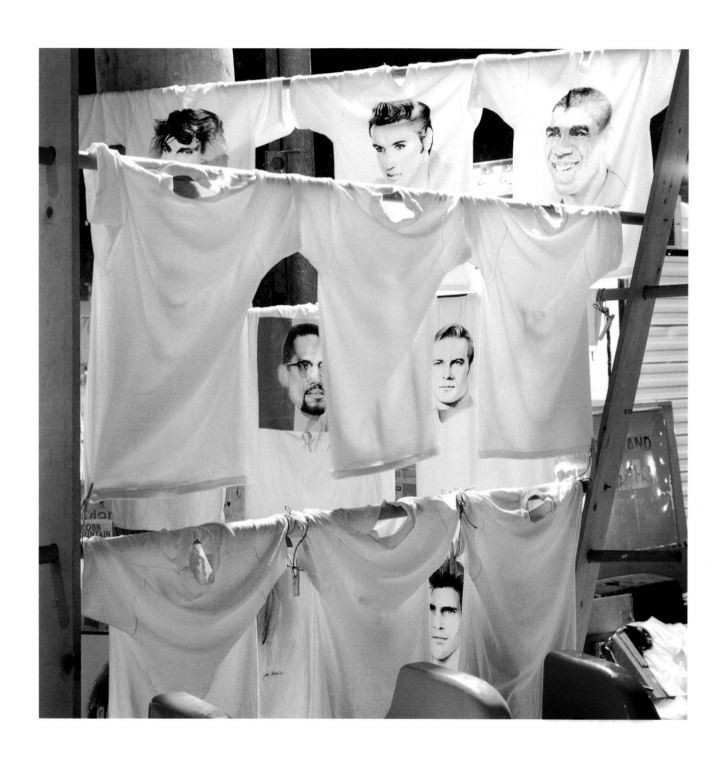

6 FACES ON T-SHIRTS / Santa Maria, California 1988

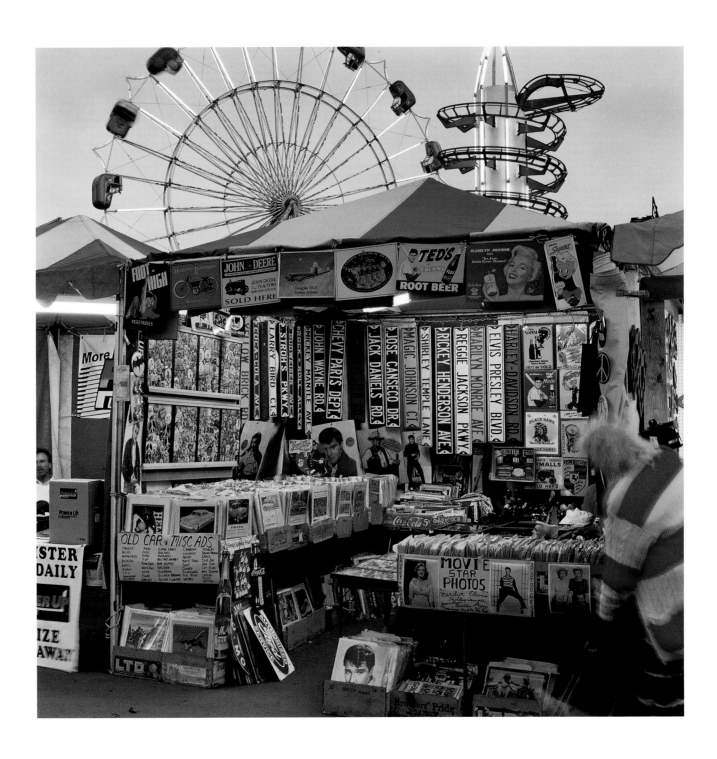

MOVIE STAR PHOTOS / Ventura, California 1990

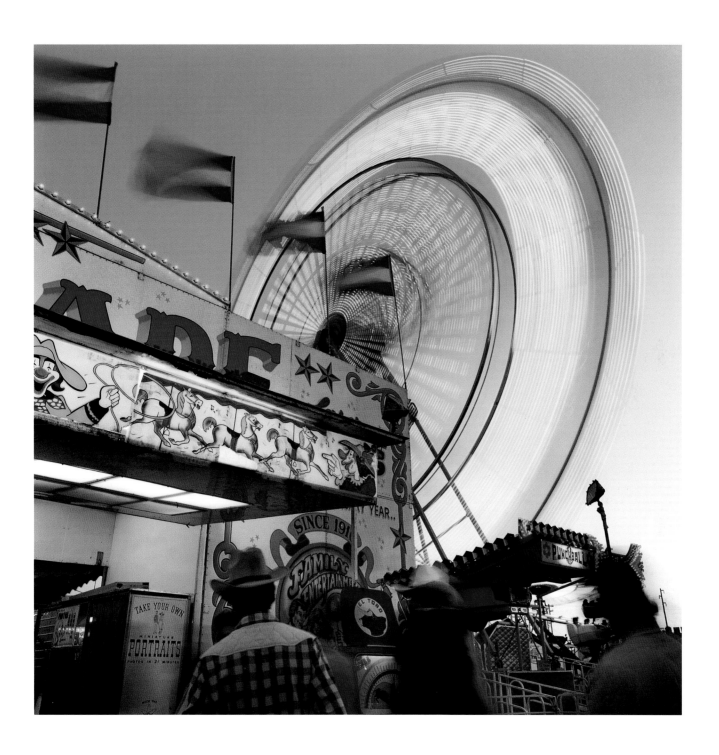

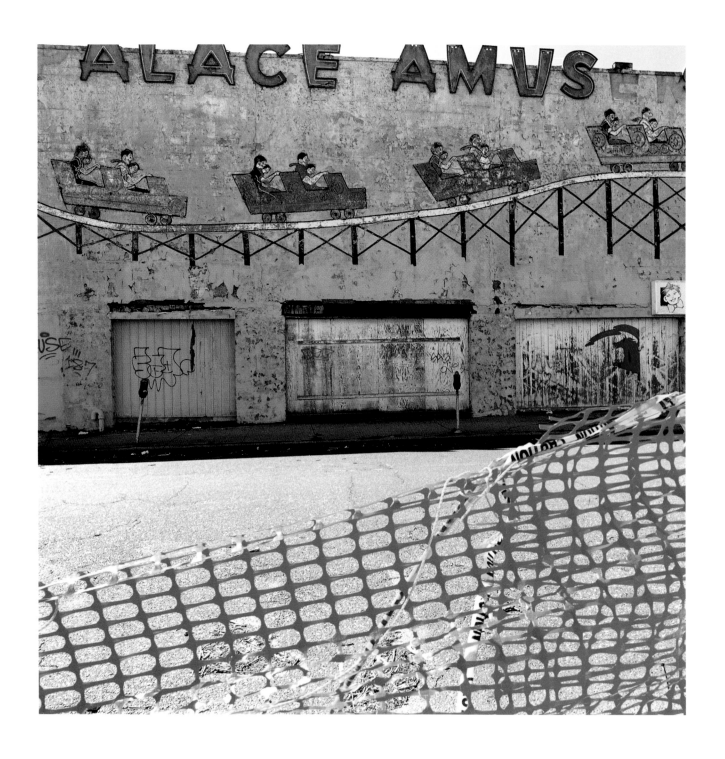

NOTES FROM THE PHOTOGRAPHER

Lingering. Wasting time. That's what I do best. As an adult I wallow in guilt over it. As a kid, however, it wasn't a problem. At eleven I didn't realize there was something else you had to do with your life besides just be here. During the summer, the season best suited for this activity, I'd while away the moments in sort of a unhurried Zen-like way. Hitchhiking from Westlake in Daly City, California, out past Lake Merced, to the Great Highway (its real name) was my favorite way to do this. At the end of the trail, before I reached the Cliff House, was my destination, my Mecca: Whitney's Playland-at-the-Beach.

Built in 1921, this ocean-side amusement park, complete with fun house, provided an incredible array of rides and games of chance. Playland was to be the first of many places in my life that would be enshrined as special, shot through as it was with character and atmosphere. It had a sense of place. Even by age eleven, Playland began to house memories for me because of the many happy moments there. As a child of divorced parents, I could go there to remember earlier times of familial unity. I also found solace and escape there as I became a teenager. Hungry for life experiences, its tawdry, down-on-its-luck presence seemed to match my own emotional state-of-mind. It was an urban landscape I could go to be by myself: free of parental constraint, free to imagine a different life.

This is what I saw and recall. A rickety old roller coaster, weathered to lush aquamarine tones, a color only salt air on corroding metal can render,

bookended the midway to the south. As I recall it had several very sharp turns that jarred and jolted; my bony build at the time made the ride uncomfortable despite the thrills.

Up the midway stood the bumper cars, enclosed in a cavernous room: a favorite at Playland. There were certain smells the ride had, ozone generated by the electricity crackling from the cars' power poles on the slick metal ceiling overhead. We drove over an oily floor that reeked of pungent shoe polish and graphite. The white, navy-surplus bell-bottom pants I often wore (the official attire for young loiterers wishing they were hippies in 1966) sustained spot-damage most of the time. In my haste to get to my favorite-colored car, I often slipped and fell despite the warning signs suggesting a slower pace.

Once inside the car (which I recall had smiling comical faces formed by their headlights and grill-work) anything was possible. All laws and rules were temporarily suspended, and if you had come with a friend, he'd better look out! Crashing and careening into one another had its curative powers. For a kid, bandied and thrown about by the whims and attitudes of the adult world, these brief moments at the bumper cars' controls were a catharsis for youthful frustrations. Thirty-five cents spent on this ride surely beats a seventy-five-dollar visit to the therapist today.

Farther down the midway stood the fun house. As one approached, the scratchy sounds of taped, over-the-top hysterical laughter filled the air. They emanated from the mechanized fat lady, Laughin'

Sal, who doubled over in the front window, her jolly convulsions beckoning you inward. (Laughin' Sal can still be enjoyed at San Francisco's Musée Mechanique, near the spot where Playland-at-the-Beach once stood.) Apparently she was privy to the good times therein. Plopping down the required six bits, in I went. They weren't going to make it too easy for you, however. Before actually gaining entrance, you had to circumvent the perils of the mirror maze.

To signal successful navigation of the maze, at the exit, blasts of hot air shot up from the floor, sending young girls' skirts up around their hips. Though at the time, the big wooden slide (and not some young girl's thighs) was on my mind instead. Off to the right was its huge, dark, tunnel-like chute. With my shoes off (you had to remove them once inside the fun house) and a piece of requisite burlap in hand, I made for the stairwell to the right of the slide that led to the top: a dark abyss. It was a narrow, crowded, precipitous climb. After ascending these thousand steps you reached heaven. Before me, divided into six rows across, was its slippery wooden surface. It's hard to describe the thrill of being seven years old and poised at this junction. From this overview, it looked like a hell of a long way down—frighteningly so—the adrenaline coursing and the heart pumping wildly. The slide itself was of polished hardwoods, similar to lanes at a bowling alley. It had three or four gradual bumps, and the ride down was swift and cool (you always worked up a sweat inside the fun house; kids free to run and scream will generate that sweet, hot smell of play). At the bottom were padded walls, ensuring a safe delivery to all who continually surrendered themselves to the forces of gravity.

In fact, many aspects of the fun house dealt with either surrendering to or defying physical laws. The ride we called the "record player" sat in front of the slides. It was a large wooden disc capable of holding approximately fifty children. It turned at a very high speed, spinning every kid off its surface, except the guy who happened to be sitting dead center. We would queue up, always hoping to be near the front of the line, hoping to attain the best position despite knowing there could only be one winner, only one person to last the whole ride. Repeatedly, most of us were pulled from the center by centrifugal forces we couldn't defy, deny, or explain. It took courage to allow yourself to be hurled, untethered, through space.

Upstairs, there was more entertainment. The Human Laundry, a revolving barrel that you walked through, ran through, or tried to stand up in, could generate a giggly dizzy spell or two. The distortion mirrors that made you skinny, fatter, or taller than you already were, were fun; a pictorial precursor showing us who we might eventually become. In retrospect it seems as though the fun house, through the act of play, became a place to simultaneously forget and discover yourself.

The fun house was generally good for about an hour's entertainment. Back out on the midway and directly across from our laughing lady was the carousel, a Charles Looff original made around the last turn of the century in Rhode Island. Its immaculate, lovingly crafted polished ponies traveled in the traditional counterclockwise direction, turning for the joy of all. Even then, I marveled at its hand-crafted beauty.

Housed in this same building were the games of chance and skill. Here among the skeeball and the

hanky-panks, I remember the naiveté that made playing these games possible: the belief that one could beat the system and win a prize. Flipping dimes into dishes and bowling over milk bottles is perpetually challenging, the potential for victory indeed sweet and only a toss away. Or so it seemed.

Unfortunately, my career at Playland and interest in photography didn't quite overlap. I have only ten frames of 35mm negs made at about age fifteen in my archive. Looking at them now, I experience a deep regret that I wasn't aware enough to under-stand what a great public place and monument this once was to the city of San Francisco. But I do realize that the nascence of my interest in cultural geogra-phy, urban studies, and abandonment and loss began here. Soon after these images were commit-ted to film, and before the historic preservationists could arrive on the scene, the wrecking ball went to work, converting Playland and its fifty-one-year history to a pile of rubble in days. Ironically, as Joni Mitchell so aptly sung in her song "Big Yellow Taxi": ". . . they paved paradise and put up a park-ing lot." And that parking lot remained just that for almost twenty years, until rising real estate values made condominium development feasible. I'm sure the city planners at the time of Playland's demoli-tion in 1972 thought it an eyesore, an unsavory place (my mother repeatedly warned me not to go there). It's just too bad it couldn't have hung on for another ten years until its historical value could be recognized. Its brother down the road—the Santa Cruz boardwalk—thankfully did not share a similar fate, although it too went through a period of decline before it was resuscitated.

In retrospect, Playland taught me quite a bit that would prove valuable throughout my life. Solving the mirror maze at the entrance to the fun house is a case in point. Symbolic of a journey I wasn't even aware I was on, I knew intuitively there had to be a correct path, but how to find it? In seeking the way, many wrong turns and dead ends were explored. But I discovered the secret: if you looked into the mirrors you only saw yourself. By looking down, staying out of your own reflection—as if not paying attention to yourself—you would find your way eventually. The path had always been there.

* * * *

I want to thank several very dear and close friends for their interest in this subject, and participation in helping to create *Inside the Live Reptile Tent*. Bruce Caron and I first started discussions on this project over eight years ago and his wit and critical think-ing on the subject proved invaluable. His excellent series of essays are a testament to his thoughtful intelligence. He never ceases to amaze me with his insight and unique take on things. I hope this book is just the beginning of further collaboration on all topics cultural. I also want to acknowledge my buddy Tom Moore for allowing us to use a selection of his fine roller coaster pictures from the Pike Amusement Park. His unabashed enthusiasm for amusement parks in particular, and photography in general, has been an inspiration and catalyst for our twenty year friendship and did help to renew my childhood interest in this subject. He also pointed the way to Asbury Park, New Jersey, for which I'm eternally grateful. Guy Williams also deserves credit for taking me to the Ventura County Fair one hot August night in 1987. His exploratory, curious

nature and early support for my initial image-making was integral to moving forward with the project. His example taught me how to work and trust one's instinct. Thanks also to Alan Rapp, for so ably shepherding this book through the rigors of the publishing world: it's been a pleasure working with both you and the talented Jeremy Stout. Two people at the Library of Congress, Jennifer Luna and Mary Ison, fielded innumerable phone calls and questions involving the Farm Security Administration photos that were used herein. I'm most thankful for their diligence in getting prints to us. Thanks also go to Leighton Kirkpatrick (Lone Wolf Color Services) for his extraordinary color-correcting abilities, and to the folks at My Own Color Lab in New York City, for their generosity. In addition, I'd like to thank Marilyn Genter at Sterling Photography in Pleasant Valley, New York, for her excellent printing and spotting abilities, as well as her endless patience. Thanks as well go to Sterling, Lori, and April.

Most important, I want to thank my wonderful wife, Wendy, who assisted me in the printing of the photographs included herein. She also designed *Reptile* (with an unparalleled eye for image-sequencing and selection, including the FSA photographs), *and* endured the agonies and ecstasies of a resident artist looking over her shoulder. She deserves a medal that hasn't been invented yet for this act of heroism.

Jeff Brouws
Red Hook, New York

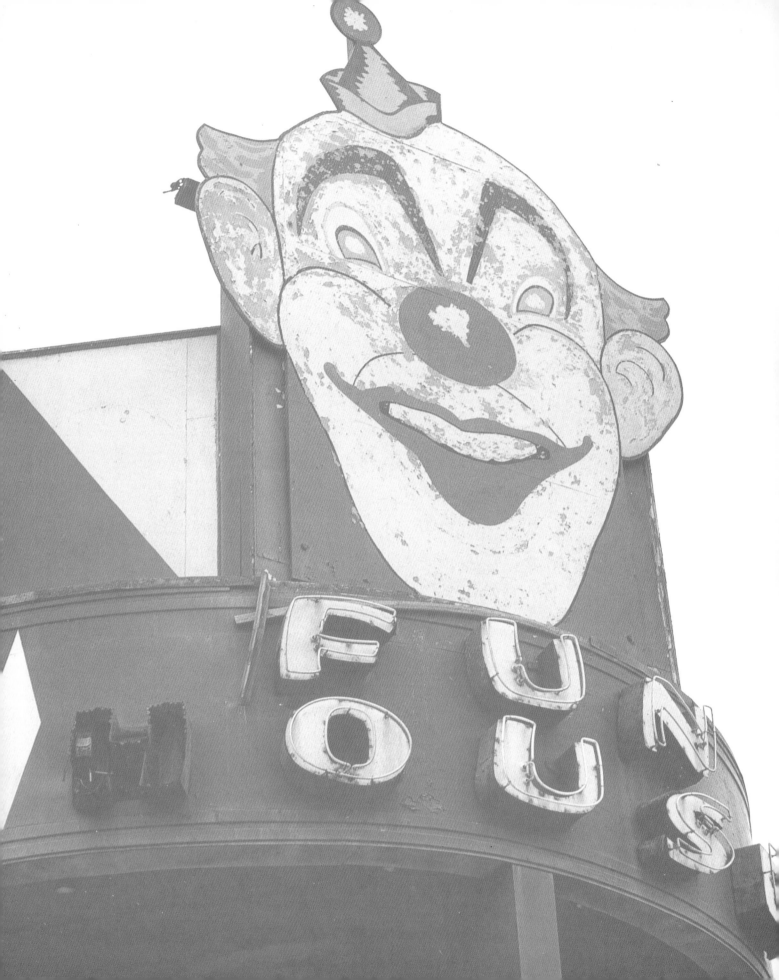